Nicholas Verrall:
Colour and Light in Oils

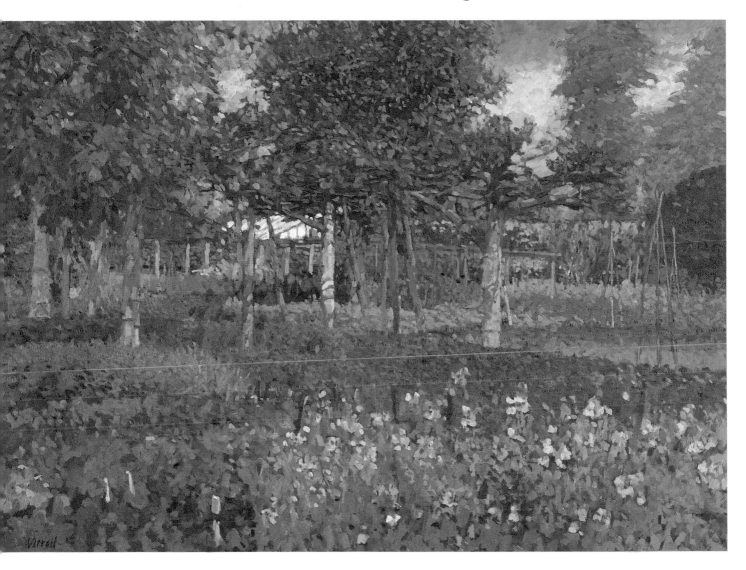

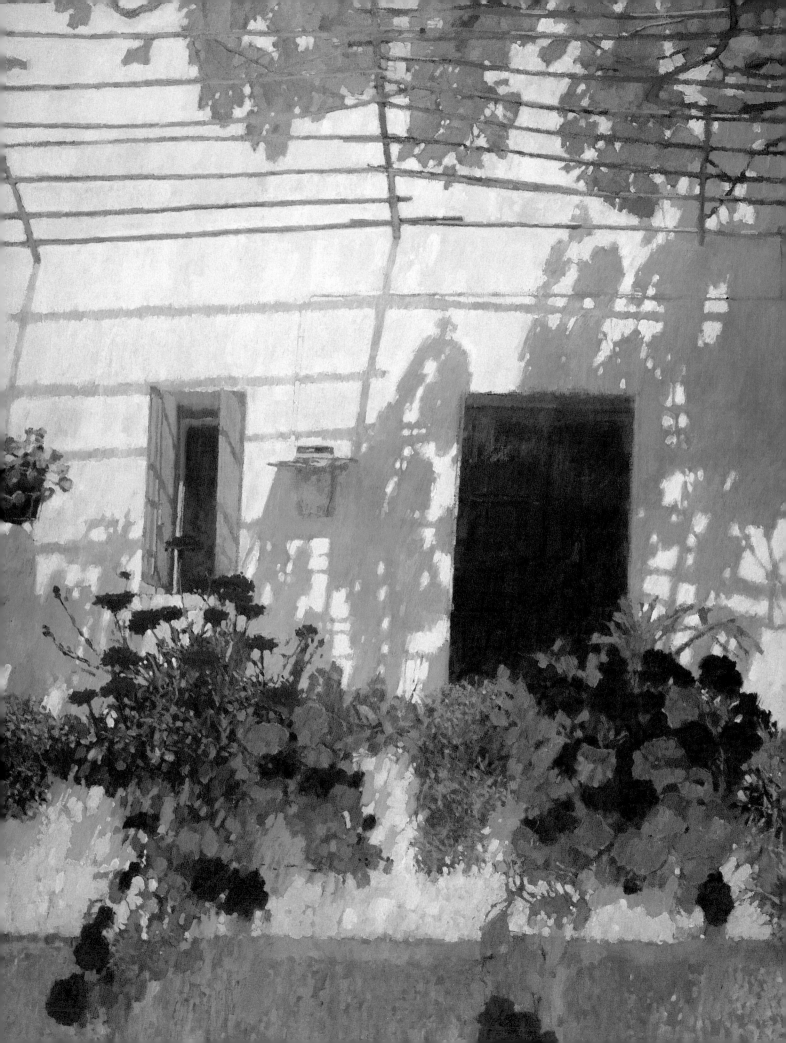

Nicholas Verrall:
Colour and Light in Oils

with Robin Capon

BATSFORD

First published 2004

Text © Nicholas Verrall and Robin Capon 2004
Illustrations © Nicholas Verrall 2004

ISBN 0 7134 8902 2

A CIP catalogue record for this book is available from the British Library.

Printed in Malaysia

for the publishers

B T Batsford
Chrysalis Books Group
The Chrysalis Building
Bramley Road
London W10 6SP

www.batsford.com

An imprint of **Chrysalis** Books Group

Half title: **1. Walled Garden**
Oil on board 60 x 83cm (23½ x 32¾in)
Title page: **2. Nasturtiums and Chrysanthemums**
Oil on canvas 122 x 109cm (48 x 43in)

Contents

Acknowledgements

I should like to thank Robin Capon for suggesting a book about my work and for his help and skill in bringing the idea to reality. Thanks also to Colin Mills and Miki Slingsby for their excellent photography, with special thanks to Colin for his patience in photographing the work in progress.

Nicholas Verrall is represented by
The Catto Gallery, 100 Heath Street, London NW3 1DP
Tel: +44 (0)20 7435 6660; www.catto.co.uk

Introduction

I have always felt that the greatest rewards in painting come from being true to yourself – in other words from painting only those ideas that really excite you, and doing so in a way that enables you to express fully what you want to say about the subject. Some painters find inspiration in their own environment and everyday lives. Others, including myself, are motivated by the challenge of the unfamiliar, of constantly varied ideas, subjects, and working methods.

However, in all my paintings, whether the subject happens to be a Provençal landscape, a balcony crowded with potted plants, a quiet interior or a Venetian antiques shop, invariably there are two elements that interest me most – light and colour. I am constantly fascinated by the way that a certain quality of light can radically alter the character and impact of a subject and make it something unique, and it is this moment of 'uniqueness' that I try to capture in my paintings through the considered use of colour.

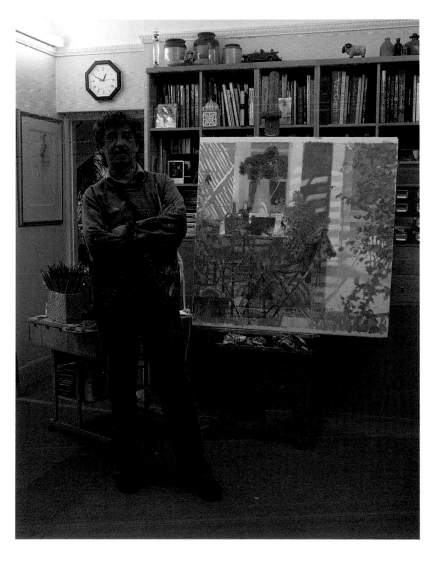

Right: **3.** *Nicholas Verrall in his studio*

I paint in oils, mainly because I like the richness and depth of colour that can be achieved in this medium and also because it suits large pictures. The size of my paintings, many of which are on canvases measuring over 122cm (4ft) wide, has partly been influenced by artists such as Monet and Bonnard, whose work I have always admired. Monet was a particular influence in the early part of my career. I was intrigued by the way in which he explored reflections on water and how he used colours and shapes flowing across a surface when making the paintings he called his 'decorations'. His emphasis was on colour rather than tone and he chose subjects that he could pull apart and then reassemble to create a new understanding of nature.

My work involves similar concepts. With the freedom that a large scale offers I often compose pictures that use both flat-pattern and three-dimensional space, thus producing a kind of tension in the work. Combined with this, I feel that a large painting can flood the surrounding space with colour and so envelop whoever is looking at it. Also, I like to explore the sort of abstract effects that are created

*Below: **4. Breakfast in Provence***
Oil on canvas 85 x 123cm (33½ x 48½in)
Light is always a quality that interests me. As here, I like the way that light and shadows can create mood and play a vital part in unifying the composition.

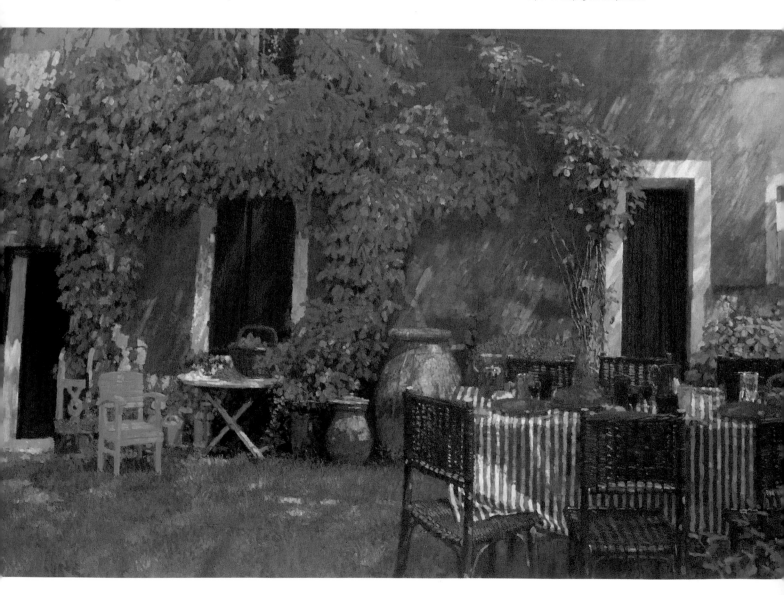

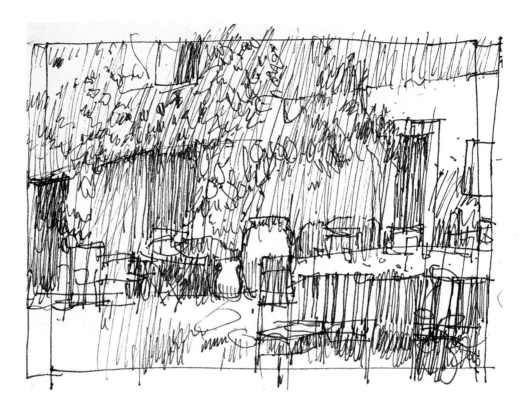

within a subject by the influence of light. It is interesting to see how the play of light and shadows can fragment an image and thus make something that is normally very easy to understand seem quite abstract.

From my student days I have always made many rough sketches when planning a painting. I use a large sketchbook, in which I make a sequence of drawings of the chosen subject, using pen and crayon. This helps me find a direction for each painting – a means of progressing from the initial vision for the picture through to the completed work without totally losing my way. It is a process that I very much recommend, although obviously it should be adapted to suit the personality and approach of each artist.

I am careful, however, not to plan anything too thoroughly. For instance, because of the way that I initially stretch a canvas, I can alter the dimensions of the painting or the proportions of the composition at any stage during the work. I have tried to devise a working practice that will help maintain my enthusiasm and excitement for the painting at every stage by allowing me the freedom to alter and improve things, yet at the same time provide me with a source of guidance. You have to strike a balance, I think, between eagerly rushing into an idea with no preconceptions and, at the other extreme, exhausting everything you want to say about a subject in the preliminary sketches.

As I have said, I enjoy the challenge of different subjects and the various ways of interpreting them, and I believe this helps to keep my work interesting and forward-looking. At certain stages with oil paintings there are practical reasons why a canvas must be left to dry, which means that I am usually working on several paintings, at different stages, at the same time. Again, this also helps in maintaining a fresh approach.

I have never taught painting, so collaborating on a book and having to think about interpretation, subject matter, techniques and so on, as well as trying to explain how and why I do certain things, has been a new experience for me. I have found it a very useful process and indeed it has encouraged me to experiment with a few techniques that I had not previously considered. In turn, perhaps the observations, information and advice that has resulted, and that now appears in this book, will also be helpful to you.

But of course there is no single method of painting that is guaranteed to bring satisfactory results to everyone who follows it. And similarly, while there are theories and 'rules' that can provide a basis for a sound painting technique, especially for beginners, such constraints are not the answer for anyone who believes, as I do, that successful painting relies on finding an individual way of seeing and interpreting. Nevertheless, just as various artists have helped and inspired me, I hope that my particular approach to painting will offer inspiration and ideas for your work and encourage you to explore the tremendous potential for capturing colour and light in oils.

Right: **6. Last of the Evening Sun**
Oil on board 38 x 35.5cm (15 x 14in)
I often paint on a smaller scale on prepared marine plywood. This has an entirely different character to canvas and, for me, encourages a more spontaneous way of working.

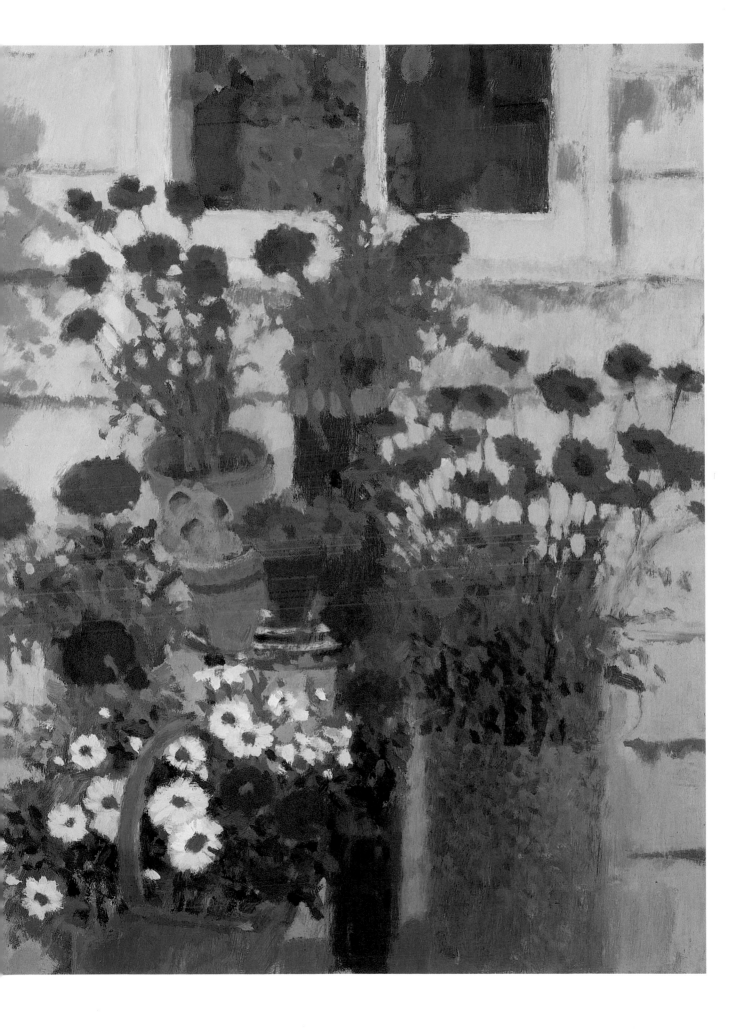

Understanding Oils

I'm not surprised that many people enjoy painting, for it is one of the most rewarding ways of expressing thoughts and feelings about things. However, gaining the confidence and ability to paint with real impact takes time. Before we can produce results that are truly satisfying we must learn a variety of skills.

Always the first important decision for an artist is which medium to use – whether to choose watercolour, acrylic, oil or some other type of paint. This is a crucial decision because the medium can have a significant influence on the scope and success of our work. So we need to find the medium that we feel most happy with, the one that offers us the greatest potential to work in a positive, uninhibited way.

Many beginners are wary of oil paint because they believe the medium to be difficult to handle and the painting process to involve complex, traditional techniques. It is true that there are certain well-established procedures and that in its 500-year history the medium has acquired a certain mystique. But there are no 'rules' and in many ways oil paint is a more suitable medium for beginners than either watercolour or acrylics. For example, the fact that it is slow-drying means there is plenty of time to assess and modify work in progress, while another advantage is its versatility: oil paint can be applied and manipulated in many different ways, from thin glazes to heavy-bodied impasto.

There is a great deal to experience and discover about oil paint and no doubt this is why, despite my art-school training, much of my understanding of the medium has been gradually acquired since my student days. In fact I have been painting in oils for more than 30 years, and during that time most of my knowledge of the medium has come simply from trying things out – building on what seems to be successful while carefully making a note of those effects, colour combinations and so on that are unsuccessful. Oil paint is a medium that will allow you the freedom to experiment in this way. Moreover, there is no other type of paint that can rival its forgiving nature and the ease with which you can alter anything you are unhappy with.

Of course, learning basic techniques is valuable, as is looking at the work of other artists. I have learned a great deal from reading books on artists such as Monet, Bonnard, Vuillard, Whistler and Sargent, and studying their paintings. Even now, whenever I am at a loss to know what to do with a painting, I seek inspiration from one of these artists. But don't rely solely on books. If you have the opportunity, visit one of the great galleries, such as the Courtauld Institute Galleries in London. Try looking very closely at part of a Cézanne painting, for example, and examine exactly how the paint was applied.

My advice is to start with the simple techniques and then, when you are satisfied with these, try more complex ones, like glazing. Don't be afraid to experiment. Naturally, practice and perseverance are also key factors that will help you develop your confidence and style. But remember too that painting isn't just a matter of applying appropriate techniques. Your paintings should also be concerned with expressing subjects in a way that shows how you think and feel about them.

*Right: **7. Conservatory Light***
Oil on canvas 132 x 122cm (52 x 48in)

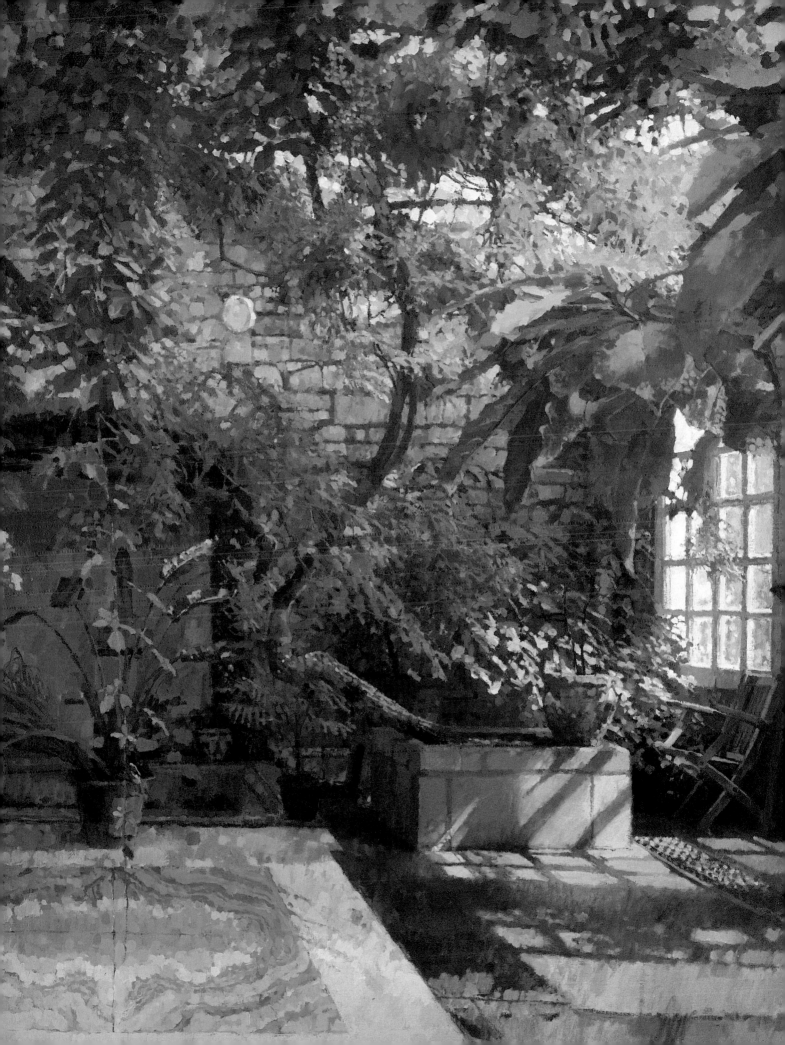

Scope and characteristics

For me, because I want the colours and paint-handling in my pictures to look fresh and spontaneous, a big advantage of oil paint is its richness and depth of colour. I can rely on the fact that a lively, vigorous quality is eminently achievable in this medium, whereas I know that such an effect would be far more difficult to produce with watercolours, for example. Like the Impressionists, I build up the picture surface by placing one rich colour against another. Although I start with an underpainting (the initial rough form of the painting, blocking-in the main shapes and colours), it is quite a different approach to the traditional monochrome technique (in which the shapes are drawn more precisely and painted with tones of single colour). Working with layers of oil paint in this way enables me to create a resonance and depth of colour that includes the underpainting as a vital part of the whole effect.

Equally, I like the consistency of the paint, its obvious 'feel' and responsive nature, and the fact that so many different surface textures are possible. I mostly work with filbert hog-hair brushes, which perhaps sounds rather restricting. But, depending on how these brushes are held and used, they will give a wide variety of thin and thick marks, and they are similarly effective for dry-brush, scumbling, stippling and other techniques, as required. You could also, of course, use painting knives, rollers, sponges, rags and many other tools and materials to apply paint if you wish.

*Below and detail above: **8. Farmhouse in Provence**
Oil on canvas 80 x 120.5cm (31 1/2 x 47 1/2in)
Oil paint will give a richness and depth of colour,
and this is a quality that I like to exploit, as in the
background area of this painting.*

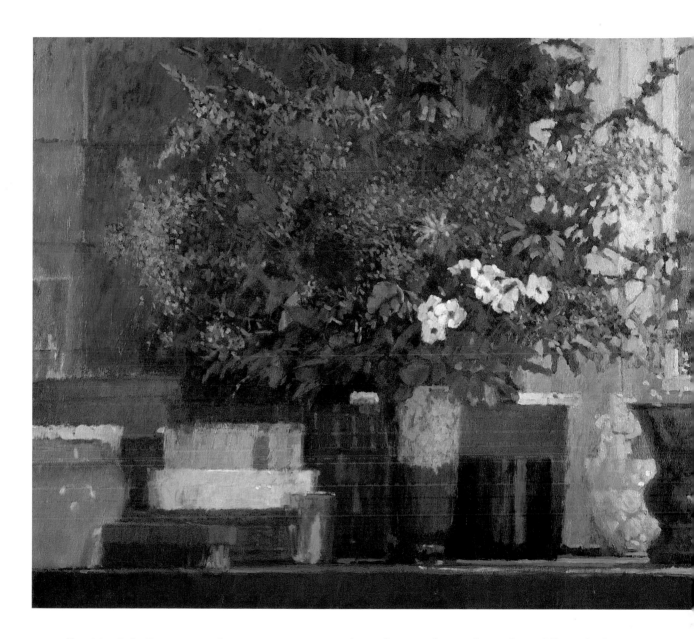

*Above: **9. Late Spring Flowers**
Oil on board 52.75 x 61cm (20¾ x 24in)
One advantage of using oil paint,
especially for a subject such as this, is
that you can create many different
surface textures.*

A common misconception about oil paint is that it only suits large, fully resolved studio paintings. Although it is ideal for such works, it is just as good for an *alla prima* approach (painting directly on a primed support to produce a finished work in a single session) and for colour 'notes' and sketches made on location. When I paint on a smaller scale, on prepared marine plywood, I adopt a different technique to that used for the larger pictures on canvas. I work in a looser, more immediate way. Oil painting allows this flexibility. And, as with other media, with experience you can begin to exploit these characteristics more intuitively.

Above: **10. Plants beneath the Vine**
Oil on canvas 115.5 x 115.5cm
(45$\frac{1}{2}$ x 45$\frac{1}{2}$in)
With larger paintings you can build up
the detail until you have the degree of
realism that you want.

What is Oil Paint?

Oil paints are made from pigments, either organic or synthetic, which are ground
to create a powder; these provide the colour of the paint. To produce a medium
that can be applied with a brush, the pigments are then mixed with a binding agent
such as linseed oil. Some organic pigments, such as rose madder and crimson lake,
are produced from plant dyes that are added to a substrate, such as alumina, in
order to form the initial powder. Other pigments are naturally occurring earth
colours. Among these are different ochres, manganese oxides and charcoal and iron
carbonates, which are used by paint manufacturers to make various yellows,
browns, blacks and reds. Inorganic pigments, such as cobalt blue and viridian, are
produced by an artificial chemical process.

The tinting strength of the different pigments varies considerably. Alizarin
crimson, for example, remains a vivid colour even when mixed with a substantial
quantity of white, whereas raw umber produces a subtle tint when added to only a
little white. Similarly, some colours are more permanent than others.
Manufacturers specify the degree of permanence on the label for each colour. For
instance, in the artists'-quality Winsor & Newton colours that I use, most colours
are marked AA, which means they are extremely permanent. Some oil colours are
opaque, but others are classed as semi-opaque, semi-transparent or transparent.
Colours such as French ultramarine and burnt sienna, which are transparent, are
ideal for glazing.

I prefer to exploit the quality and formulation of the paint as it is, rather than add different mediums and diluents. To thin and mix colours I only use pure turpentine, although as explained on page 24, I usually add a little matt medium to the white. The matt medium prevents the colour 'sinking' – drying with a dull finish. In my experience it is best not to use lots of linseed oil as a thinning agent, particularly in the early stages. If you start with oil-rich paint this can result in problems later on, as the paint dries. The more oil there is in the mix, the more likely it is that the surface of the paint will dry quicker than that underneath, causing it to crack.

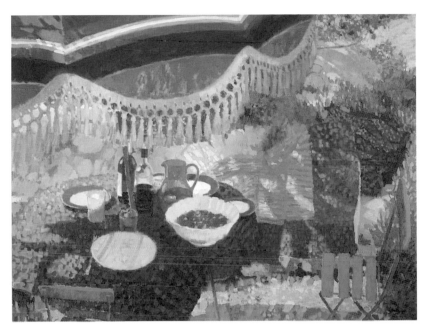

Right: **11. Le Parasol** *Oil on canvas 106.5 x 134.5cm (42 x 53in) Colour is invariably the most important element of the painting. A feature that I like about oil paint is that I can start with muted colours and then gradually add stronger ones to develop the right colour relationships and effects.*

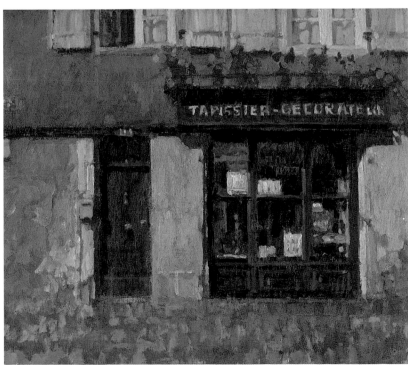

Right: **12. Le Tapissier** *Oil on board 30.5 x 35.5cm (12 x 14in) This shop front reminded me of similar subjects that Whistler used to paint on cigar boxes when he was out sketching in Dieppe. I decided to apply some of the techniques and effects that I liked in his work.*

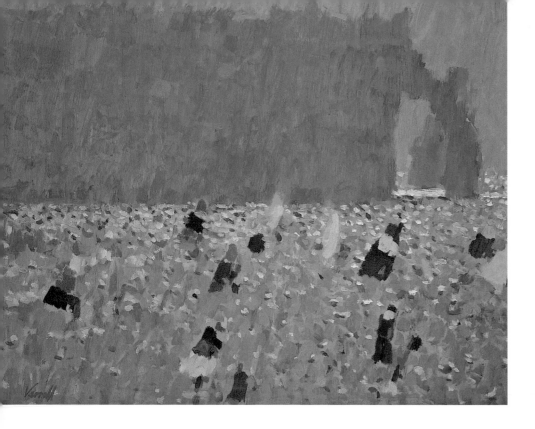

Drying time is another variable aspect of oil paints. Particularly when linseed oil is the only binding agent used, some colours are faster-drying than others. Raw sienna, for example, will normally be touch-dry in about two days, whereas titanium white takes up to eight days. But manufacturers usually compensate for this by using safflower or poppy oil as the medium for quicker-drying colours, instead of linseed oil. This slows down their drying time, so that all the manufacturer's colours will dry at a similar rate, helping to prevent surface cracking. This is why I would advise you to keep to one brand of paints. The formulation and characteristics of different brands do vary – not only drying rates but also paint consistency, handling qualities, permanence, and so on.

A Forgiving Medium

Once you have blocked in an area with acrylic paint or applied a watercolour wash, that particular area becomes a permanent part of the painting. Both acrylic and watercolour paintings dry quickly, making it extremely difficult to remove colour without damaging the picture surface. Oil paint, by contrast, is slow-drying and this is a quality that can be used to advantage.

Because there isn't the pressure to get everything right at the first attempt, I believe oil painting can encourage a more relaxed, confident attitude. There is time to try out different possibilities and to consider the composition, colour, tone and other aspects of your work and, if necessary, to make adjustments. Thin oil paint is easily removed by wiping across the area with a slightly turpsy rag or some tissue paper, while a thicker layer can be scraped off with a palette knife.

The forgiving nature of oil paint can be a distinct benefit when trying to capture a certain quality of light. There is no intrinsic light in a painting of course; the light effect is conveyed by the use of colour and tone. So it is extremely helpful if there is time to evaluate and, if necessary, modify the development of the light effect you are creating. In all my paintings I am concerned with areas of light. These are fundamental to the composition and the impact of the work. What I am trying to achieve is a flow of light from some outside source to a focal point within the picture.

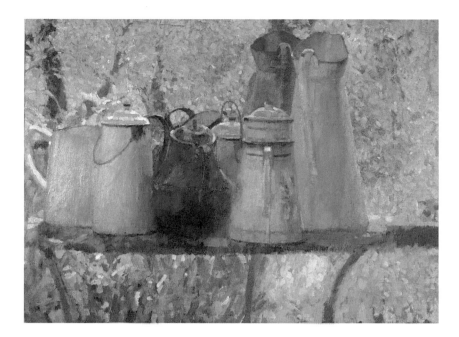

Right: *14. Still Life with Enamel Pitchers*
Oil on board 45.5. x 61cm (18 x 24in)
Again here, I have tried to exploit different
textural possibilities. The calmness of the
paint on the pots contrasts with the more
freely worked background, which creates
both depth and interest in the picture.

Equipment

While the studio of an established artist might well contain an extraordinary range of materials and equipment, it is surprising what a small number of items you actually need to start with – just a basic selection of paints and brushes, some turpentine and a surface to paint on, which could be inexpensive primed hardboard or MDF (medium-density fibreboard).

Art shops are full of tempting materials, but until you have gained some experience with oil paint my advice is to keep to the minimum, perhaps experimenting with one or two different brands of paint, types of brushes and so on. When you find paints and other materials that you like and that you think will help you achieve the best results, then gradually add these to your range of equipment.

Right: **15. Dianthus**
Oil on board 43 x 51cm (17 x 20in)
When using board, because the
scale is smaller and the subject matter
usually less complicated, you can adopt
a more straightforward, dark-to-light
painting method.

Painting Surfaces

Most artists paint on prepared canvas or board. You can buy canvas of various grades and apply the sizing agent and primer yourself or, as I do, buy ready-prepared canvas. I used to stretch and prepare my own canvases but this is time-consuming and it can be unreliable. If the primer isn't applied properly there can be a problem with the paint lifting or cracking later on. I now work on oil-primed Belgian linen canvas, which I order by the roll (at a standard width of 213cm/84in wide) from L Cornelissen & Son in London.

With such an oil-primed canvas, I find that the paint does not sink in as much as it does on an acrylic-primed surface. I choose a linen canvas because it is stronger, has a less-pronounced texture, is softer to the eye and is a more subdued colour than cotton canvas.

My method of working on canvas is unconventional in that initially I stretch the approximate shape and size that I think I need over a sheet of fibreboard, rather than across a traditional wooden stretcher. This gives me the freedom to increase or decrease the size of the picture as I wish and it also means that I can stack paintings without them 'denting'. Pre-stretched canvases are sold in set sizes – 61 x 51cm (24 x 20in), 76 x 61cm (30 x 24in), 91 x 71cm (36 x 28in) and so on – and I've always found this a bit restricting.

Some artists like the 'spring' feel of a traditional stretched canvas, a quality that of course is lacking in the hard surface that I paint on. But I've never found this a problem, perhaps because I have always been used to working in a similar way in pastels. You can treat the canvas with a tint or coloured ground before starting the underpainting, as a sort of neutral tone and to get rid of the white. This was something I used to do in the past, although now I prefer to work directly onto the off-white surface, as I think this helps give some resonance to the subsequent layers of colour.

For smaller paintings, perhaps a still life or a location study, I often paint onto board. I use marine plywood, prepared with a coloured ground made from oil primer tinted with a little purple-grey or brown-grey oil paint, depending on the subject. The ground is worked across and into the surface of the board using a plastic squeegee, which forces the colour into the grain. Then the board is left to dry for about two days before I apply a second coat.

Wood has an entirely different character to canvas. The paint seems to rest on the surface and the texture and grain of the wood add a further, interesting quality, encouraging what seems to me to be a much more spontaneous way of working. For example, in *Dianthus* (see page 19), in addition to a range of brushwork techniques, I have been able to make use of the original ground colour and texture of the board, allowing it to show through in places. Note that this painting is quite different in its appearance and 'feel' from *Ciel d'Azure* (see opposite), which was painted on canvas.

I only use these two types of painting surface (known as 'supports'). However, you may want to try some other surfaces to paint on, such as hardboard, MDF (medium-density fibreboard), canvas board or oil sketching paper. Board and similar absorbent surfaces should be given a coat or two of primer before use. Depending on the kind of work you have in mind, you may prefer a surface that is entirely smooth, or quite textured.

Right: **16. Ciel d'Azur**
Oil on canvas 127.5 x 112cm (50¼ x 44¾in)
Canvas is ideal for large-scale pictures that involve a variety of painting techniques. I prefer to work directly onto the off-white surface, applying an appropriate weak-tone underpainting (in this case pale mauve) and later adding stronger colours. This gives greater resonance to the final layers of colour.

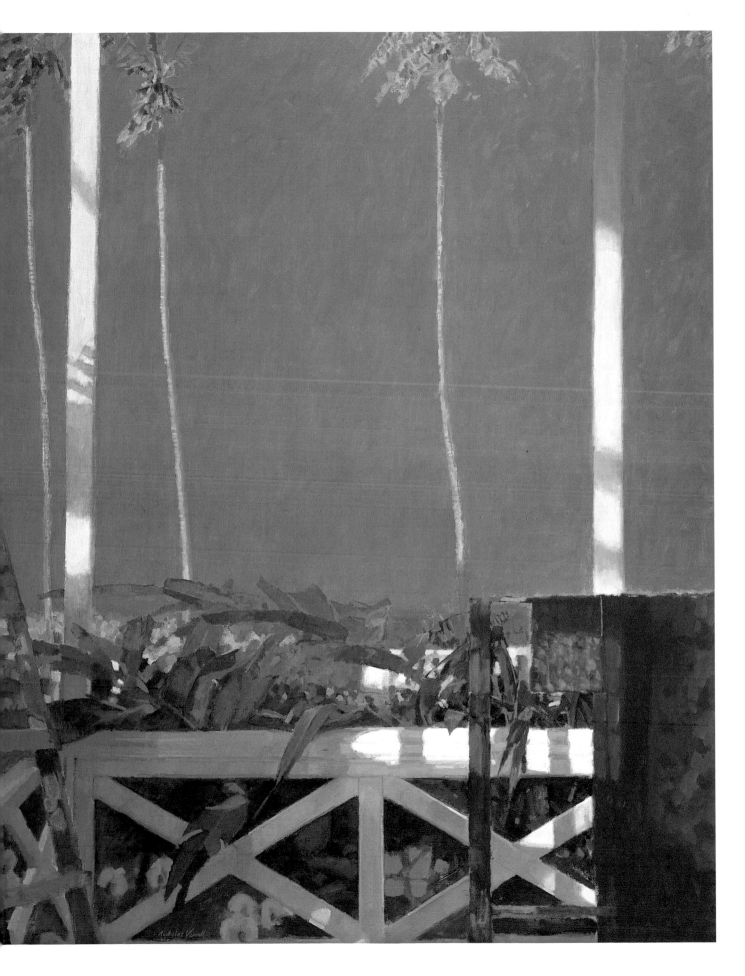

Paints

Since Victorian times oil paint has been available in tubes and manufacturers now usually offer a choice of tube sizes (21ml, 37ml and 120ml), with white also sold in large tins. There are two grades of paint – artists' quality and students' quality.

Most of my paints are from the Winsor & Newton range of Artists' Oil Colour. These paints have known characteristics, in that they have a high pigment content (ensuring rich, vibrant colours) with good handling qualities and tinting strength, and I know they are going to last. But the less expensive students'-quality paints are a good alternative for anyone new to oil painting. The difference is that the students' colours contain more extenders and less pigment, with some of the more costly traditional pigments replaced by modern, synthetic ones.

As explained on page 18, the oil content, consistency and handling characteristics can vary from one brand of paints to another. It is a matter of finding a brand that feels right for you. Then you need to choose a palette (a selection of colours) to work with. Most manufacturers produce a huge range of colours – there are 120 colours in the Winsor & Newton range of Artists' Oil Colour, for example – and this may encourage you to think that you need a wide selection to achieve the best results in your paintings. In fact, a limited palette will prove more successful.

For most paintings I use the following 15 colours, which I arrange around the edge of my palette, right to left, as follows: titanium white, cadmium yellow, yellow ochre, raw sienna, cadmium orange, cadmium red, permanent rose, permanent magenta, permanent mauve, French ultramarine, cobalt blue, manganese blue, viridian, Venetian red and raw umber. No artist needs more than this number of colours, although they might choose a different blue, yellow or other colour from the 120 colours on offer. These are more or less the colours that I used when I worked in picture restoration and I have found that I can mix any colour I need from this selection. It is a fairly traditional palette, rather like Monet's, for example.

You will notice that I don't include black or many browns. I prefer to make a rich, dark colour similar to black by mixing raw umber and French ultramarine. This gives a colour that is less flat and dead than black, although I accept that true black can be effective in some paintings. I make a variety of browns by mixing cadmium orange and cadmium red with different greens and blues.

Brushes

I prefer bristle brushes to ones made with synthetic fibres. Bristles are tough and springy, will give an interesting variety of marks and effects, and they last well. They bring out the characteristics of oil paint in a much more positive way than sable brushes, so it is worth persisting with them. Buy the best-quality brushes you can afford. Good brushes keep their shape for a far longer period and they are better at holding the oil colour and moving it around the painting surface. Oil-painting brushes need to be hard-wearing, for inevitably they are subjected to some harsh treatment against the canvas or board surface as well as from the effects of solvents.

Brushes come in a number of different shapes – brights, flats, filberts and rounds – and with the choice of short or long handles. As an alternative to hog-bristle brushes you could choose one of the less expensive nylon, polyester or other synthetic hair types, while soft sable brushes are useful for painting fine details.

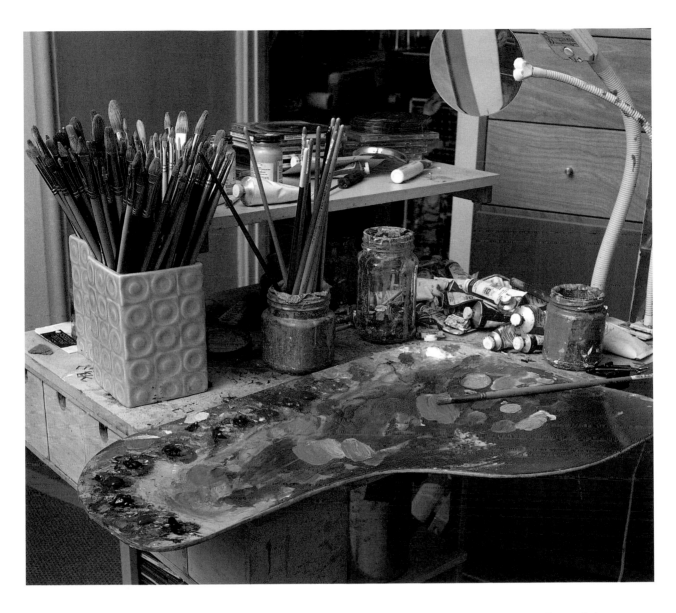

*Above: **17**. My brushes and palette.*

My bristle brushes are mainly filberts (a flat-shaped brush with rounded corners), and because I want fresh-looking colour and crisp brushstrokes, I often use 20 or 30 brushes during a day's work, keeping each brush for a particular colour (using a fresh brush each time a new shade is mixed from two or more existing colours). When I have finished with each brush during a particular session of work I drop it into a pot of white spirit. Then I leave it to soak in the solvent overnight and clean the whole batch of brushes the next morning, before I begin painting again.

The pot of white spirit is so designed that the hairs of the brushes rest on a sheet of fine wire mesh, suspended above the bottom of the pot. This allows all the paint sediment to fall through the mesh and accumulate at the bottom of the pot, thus ensuring that the brushes are always standing in clean solvent. I have the same arrangement for the pot of refined turpentine that I use for mixing paints. To clean the brushes I rinse them with white spirit, holding them over my palette, and then I wipe each brush several times with a turpsy cloth. Then I clean the palette. It is important not to let paint harden on the bristles: regular cleaning will keep your brushes in good condition.

Diluents and Mediums

Turpentine and white spirit are diluents, and these are used to thin the colour and to clean brushes and equipment. I prefer turpentine for thinning and mixing colours. It has a more viscous nature than white spirit and allows greater sensitivity in controlling the paint. Another advantage of turpentine is that it partially acts as a binder, whereas using too much white spirit will dilute the binding oils in the paint and affect its adhesion. Colours thinned with white spirit have a matt look, while those thinned with turpentine maintain a slight gloss. Both white spirit and turpentine have a pronounced smell. Some artists find this difficult to work with and instead choose a low-odour solvent such as Sansodor.

Different additives (called 'mediums') can be used to influence the drying time of the paint or alter its handling characteristics. Linseed oil, for example, retards drying time and improves the flow of oil colour. Other mediums act as an extender, to make the paint go further, or they change its consistency so that it is more suitable for texture and impasto work. My advice is to avoid using these mediums until you have some experience with the way unaltered oil paint behaves and you see a specific need to enhance or alter its basic characteristics.

The only medium I use is Matt Spectragel, which is made by Spectrum. I add this to the white oil colour in a ratio of about 10 per cent Spectragel to 90 per cent paint. In turn, this white is added to most other colours. The matt medium gives extra body to the paint, slightly speeds up its drying time and helps create a uniform, fresh-looking surface quality to the work. It can also be used in a similar way to retouching varnish. If an area of colour 'sinks' for some reason, I will paint over it with a thin wash of Spectragel (a mixture of 15 per cent Spectragel and 85 per cent turpentine) to bring it back to life.

Other Equipment

The other essential items of equipment include a palette, an easel, containers for turpentine and plenty of rags for cleaning brushes and so on. Traditionally, mixing palettes for oil painting are oval, rectangular or kidney-shaped and made from mahogany or a similar, lightweight hardwood. They have a thumbhole so that you can hold the palette in one hand while you stand and work at your easel. Various sizes are available and in general the size you need will depend on the scale of work you envisage.

Of course, it isn't necessary to use a conventional palette. You could simply use a piece of plywood, for example, or even the top of an old table. But first seal any absorbent wooden surface by rubbing some linseed oil into it. Many well-known artists had unusual palettes, notably Seurat, whose palette was a tin lid, and Picasso, who often used a newspaper as his palette. And, as described in the next section (The Studio, see page 25), my palette is unconventional too!

Some sort of easel is necessary and although it isn't essential to work standing up – I prefer to sit – it is helpful to have the canvas or board fixed in a fairly upright position and to be able to adjust this angle as required. Painting at an easel also allows you to step back now and again to check how the work is progressing. There are many different types of easel, from lightweight sketching easels that are portable and used on painting trips, to sturdy, elaborate studio easels. Again, the choice must depend on what best suits the individual artist, although many painters find that a good compromise is a box easel. This is robust enough to use in the studio for quite large pictures, yet will fold down to a compact shape for outdoor work.

The Studio

Oil painting can be a messy business and, if you want to paint regularly and produce pictures of a reasonable size, it does require a fair amount of space. However, not everyone is fortunate enough to have a separate studio and many artists manage perfectly well by using part of a room or even by confining their workspace to the kitchen table. I now have a studio consisting of two main areas: one is used for painting and the other provides storage space for paintings in progress, finished work and other items.

I know that some artists like a sparsely furnished studio – without home comforts that might tempt them to take it easy – as this encourages them to focus on their work. But I believe a degree of comfort can be helpful and the studio itself should create an inspirational environment. I have a lot of books in my studio, a sofa where I can sit and enjoy a cup of coffee, and a table in front of the large window where I sometimes set up a still-life group to paint. There are usually photographs and sketches on the walls that relate to the work in hand, although I don't have any paintings on display. When I'm working on a subject I prefer not to be influenced or distracted by other paintings. The studio should be a place that you are eager to go to every day.

Studio Equipment

The main pieces of equipment in my studio are the easel, the adjacent table with its built-in palette, a large mirror and my chair. As mentioned above, I prefer to paint sitting down, so I have a swivel chair, rather like an office chair, which is on castors and consequently is very manoeuvrable. This means that I can easily adjust my working position or push back away from the canvas to view the painting from a distance. On the wall behind my chair there is a large mirror. I find this very useful because viewing a painting as a mirror image gives me a different perception of it and it also exaggerates any weaknesses in the composition!

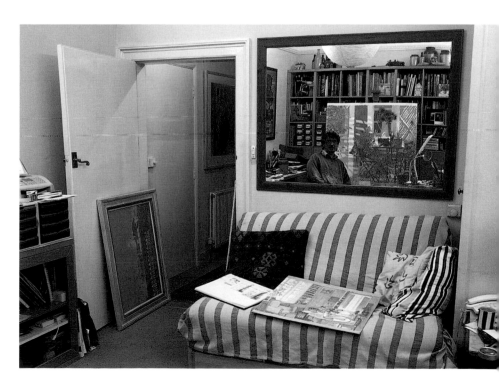

*Right: **18.** Part of my studio, showing the large mirror on the wall behind my sofa.*

The easel is a large 'H' shape wooden studio easel, which will take canvases up to about 152cm (60in) high. However, because I am sitting down, I sometimes find it difficult to reach the top areas of a large painting. I can lower the canvas to the floor, but as the next setting on my easel is about 45cm (18in) above the floor, if I want a height somewhere in between, I must improvise by supporting the canvas on a box.

The palette I use was made by my father many years ago. Unusually, although it looks like mahogany, it is actually made of melamine. Another unusual feature is that it is screwed to the top of a table, an old computer desk. This prevents it moving about while I am mixing colours. A big advantage of the melamine surface is that it is easy to clean. I can even resort to using paint stripper for any dried-on paint that can't be loosened with a palette knife, and in 30 years this has never damaged the surface.

I also have a smaller wooden palette that I use for location work. This is kept with some paints, a few brushes and other useful painting and sketching materials in the wooden box that I take with me on my painting trips. The box, which was also made by my father, is so designed that it will hold all the essential equipment for plein-air work in a compact way, and with due consideration to weight – making it easy to carry around. I don't use an easel outside. Instead I usually prop up the painting board on the ground or rest it on my knee.

Lighting

One of the most important aspects of studio organization is the lighting. Good lighting is crucial, otherwise there can be problems in assessing and mixing colours accurately and consequently developing the painting as effectively as you can. Ideally, the strength and direction of the light should be consistent throughout the duration of the painting. If there are variations in the quality of lighting it makes it very difficult to maintain the right balance and relationship of tones, colours and other elements.

*Below: **19. The White Courtyard**
Oil on canvas 98 x 139.5cm (38³/₄ x 55in)
There is far more scope when working in
the studio, both with regard to the size
of the painting and because there is time
to consider things more thoroughly.*

*Above: **20. Fruit Tree, Grasse***
Oil on canvas 109 x 111.5cm (43 x 44in)
For a large studio painting such as this I
work in stages, gradually developing the
strength and relationships of the
different colours over a period of time.

Most people's idea of an artist's studio is a room with large, north-facing windows. Whilst it is true that a north light (in the northern hemisphere; a south light in the southern) has the advantage of being a neutral, cool light, with no direct rays of sun or changing shadows, this is not to say that other types of light are totally unsuitable. In a room where the natural light comes from another direction it is usually possible to counteract any variation in the lighting by using window blinds or artificial lighting.

I personally find a north light depressing: I'd rather see the sun shining through the window! My studio is south-facing so, during the middle of the day, if the light is particularly strong, I lower the blinds, which are of a kind that diffuse the light passing through them rather than blocking it out. Additionally, the studio is fitted with simulated daylight strip lighting – special fluorescent tubes that, unlike most artificial lights, mimick sunlight and enable one to see colours properly. I leave these on all the time when I'm working and on the opposite side of the room I have an upward-facing light with a halogen bulb that casts a bright white light on the ceiling. This means that there is never any obvious change in the studio lighting while I am working, for when the natural light is poor, the artificial lighting compensates for it.

Painting Techniques

I believe that painting is essentially an instinctive process rather than a methodical one. Nevertheless, for an oil painting to succeed there are certain procedures that must be borne in mind, and it also helps if we can call on a wide range of techniques. In time, with experience and confidence, we learn to adapt the basic techniques to fit our own objectives, and in so doing create our own style of work. The first two important things to appreciate about oil painting are that the support must be prepared in an appropriate way (see page 20) and that the paint interacts and dries best if it is worked 'fat over lean'. This means starting with paint that contains very little oil ('lean' paint – that is, paint thinned with turpentine) and then gradually developing the painting with thicker and 'fatter' (oil-rich) colours on top. The purpose of this is to avoid the problem mentioned earlier: surface cracking caused by top layers drying faster than paint underneath. Some artists add linseed oil or other oils or mediums to the colour mixes during the latter stages of a painting in order to achieve this gradual change in 'fat' content. But, as I have explained on page 24, it is possible to adopt a freer working method if you only use turpentine as the diluent.

Underpainting

The underpainting is the first stage of the painting and it is usually made with thin paint, blocked in fairly quickly and loosely. For me, the underpainting serves three main purposes: it subdues the white surface of the canvas; it establishes the general composition (the position of the main shapes); and it creates a basis for the eventual colours of the painting. I often use contrasting or complementary colours in the underpainting to enhance the succeeding colours.

Below left: **21. Tuscan Terrace**
(Stage 1)
Oil on canvas 120 x 97cm (47¼ x38¼in)
I usually begin by blocking in the main areas of colour in this way.

Below right: **22. Tuscan Terrace**
(Stage 2)
Oil on canvas 120 x 97cm (47¼ x 38¼in)
Once the initial colours are dry, I spend some time developing the different tonal relationships and surface textures, with a particular time of day or quality of light in mind.

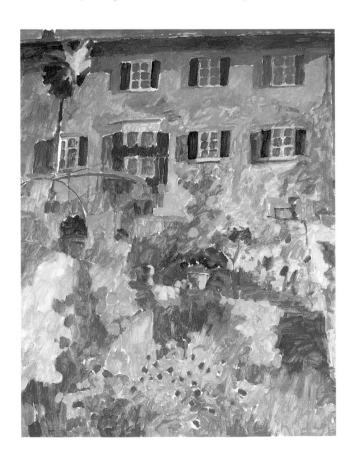

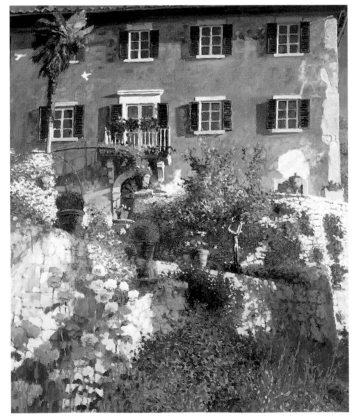

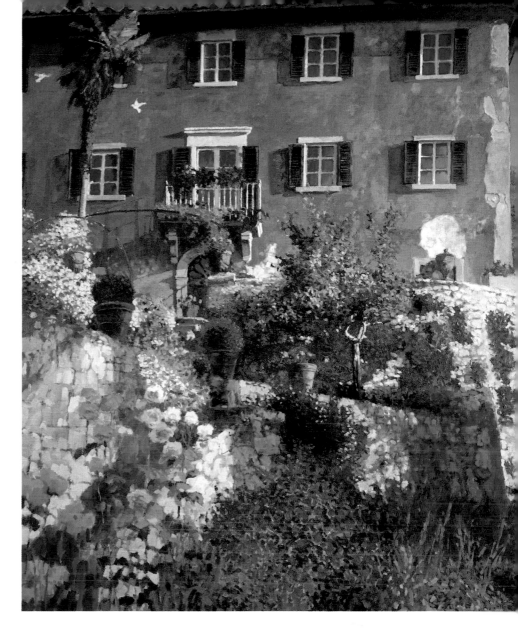

Generally I keep to just one or two cool colours, perhaps blues, purples, greens or browns. For example, if most of the final colours are going to have a yellow bias I will probably make a purple underpainting. Then, when the yellows are applied over it, they have more impact. Another point about the underpainting is that you can let touches of it show through in places to add variety and interest. This was so in *Rivage Méditerranéen* (see page 30), for which I used a purple underpainting, making the rocks and foreground area a darker tone than the sea.

Blending

There are several blending techniques that are useful when painting, particularly for subjects that require a soft, gradated effect from one colour to the next with no perceptible edges.

The usual way to achieve this effect is to start with separate bands of colour and then, with a clean, dry brush, drag and merge each colour into the adjacent one. Use a stiff brush to begin with and then finish with a softer brush and a lighter touch to produce a really smooth, subtle blend of colours. Normally this technique is applied to colours that are closely related – a series of blues in a sky, for example. Bear in mind that if you blend some colours, say blue and yellow, you will create an entirely different colour.

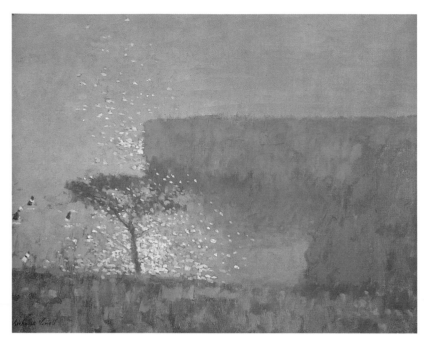

Left: **24. Rivage Méditerranéen**
Oil on board 52 x 66cm (20½ x 26in)
Here, I started with a purple-grey underpainting, working over this with increasingly lighter colours until I had created the sense of light and mood that I wanted.

Below: **25. Les Ombres Bleues**
Oil on canvas 101.5 x 106.5cm (40 x 42in)
A blending technique using separate brushstrokes that are slightly merged together is ideal for a large background area like this, where there are subtle changes of light and shadow.

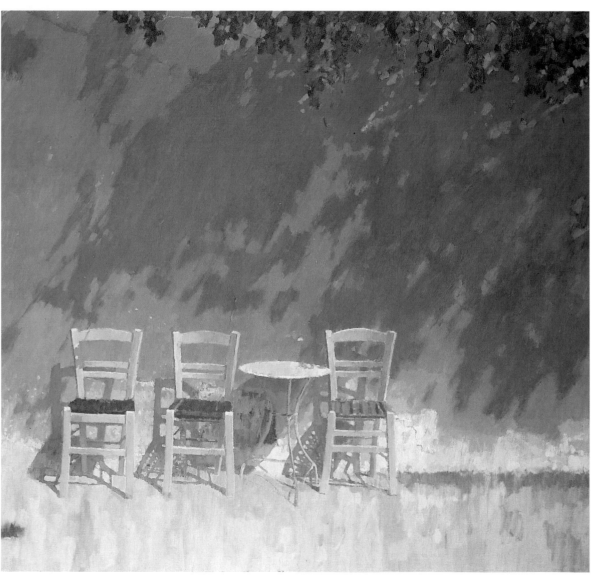

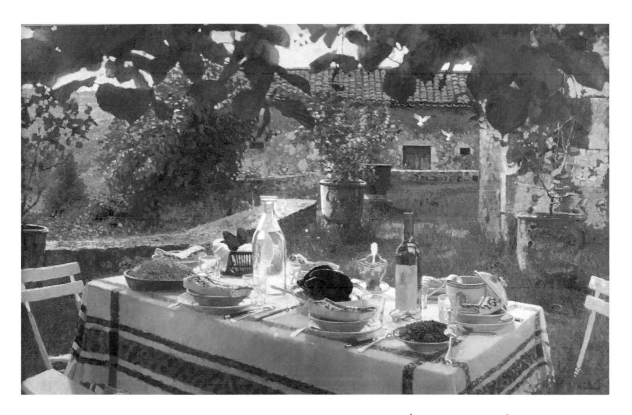

Right: **27. Le Déjeuner en Provence**
Preparatory study, fibre pen.

Alternatively you can paint one colour on top of another — a sort of wet-in-wet approach — and you can also create a blended effect across an area by intermingling and perhaps slightly overlapping brushstrokes of different colours. I often use a blending technique when painting shadows, but as in *Les Ombres Bleues* (see opposite), my preferred way of working is to build up the area with separate brushstrokes that are only slightly merged together. A similar method works for skies. I like the colours to look fresh, and the danger with blending is that it can lead to muddy colours.

Blending is also useful when you want something in a painting to recede, whereas separate brushstrokes tend to bring things forwards. In *Le Déjeuner en Provence* (see above), for example, I have used a blending technique across most of the foreground table area, so that it is not too pronounced and will allow your eye to travel back into the picture, where incidentally the brushstrokes are more obvious. Variety of this kind is both constructive and interesting in a painting. If everything is too precise a painting can look stilted and lack vitality.

Broken Colour

Here, the brushstrokes are kept separate, not blended, and they are applied over a dry surface so that they retain their character and texture. Use a fresh brush for each colour.

I sometimes choose this technique for certain light effects, such as a dappled light; for different surface qualities, like the rippling water in *St Tropez, Evening* (see below); or to add interest to what would otherwise be a fairly empty and unexciting background area. Broken colour is particularly effective when used in contrast to more resolved areas of a painting. It gives an Impressionist feel and it makes a good plein air technique, because rather than pre-mixing the colours you can work faster and achieve a more lively effect by using interspersed dabs of different colour applied directly to the canvas.

John Constable was one of the first artists to use the broken colour technique. His green fields, for example, look more convincing and interesting because they are painted with brushstrokes of varied hues, rather than as a single colour. Later on, the Impressionists took this idea further, employing a method that became known as optical mixing. In a shadow area, for instance, they often used a carefully considered mixture of blue, green and violet dabs of colour, applied as very small dots or blocks. From a distance this mixture reads as a single colour, though one that flickers and vibrates, just like the light itself.

Below: **28. St Tropez, Evening**
Oil on board 46 x 61cm (18 x 24in)
I chose mainly a broken-colour technique for this subject because I thought it would help convey the effect of the fading evening light and the shimmering surface quality of the sea.

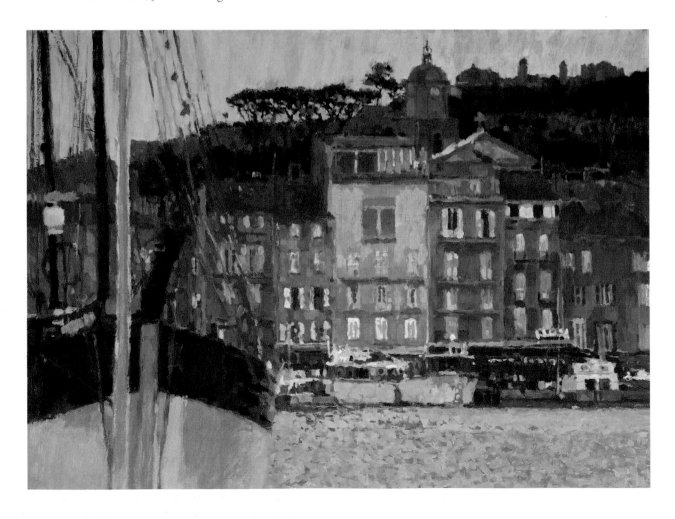

Glazing

A glaze is a thin, transparent layer of paint that is laid over a previously painted, dry area of colour to modify it in some way, although not completely obscure it. You can make a glaze by thinning paint with a glaze medium, such as Roberson Glaze Medium, or as I do, by thinning with turpentine mixed with a small amount of Spectragel medium (in the ratio 85 per cent to 15 per cent). Turpentine on its own is not entirely suitable: the Spectragel helps to create a glaze that flows more easily and has a slight lustre.

I use glazes for certain light effects, as in *Draperies au Soleil* (see below), for shadows, and for parts of a painting where I want a translucent quality or a rich, luminous depth. Glazes can be applied at any stage in the work, over thin or thick paint, in specific areas or across the whole painting. I generally use a large filbert brush to apply a glaze: some artists prefer a soft-haired brush.

*Below: **29. Draperies au Soleil***
Oil on canvas 117 x 127cm (46 x 50in)
I used a sequence of thin glazes here to build up the transition of colour from one side of the painting to the other.

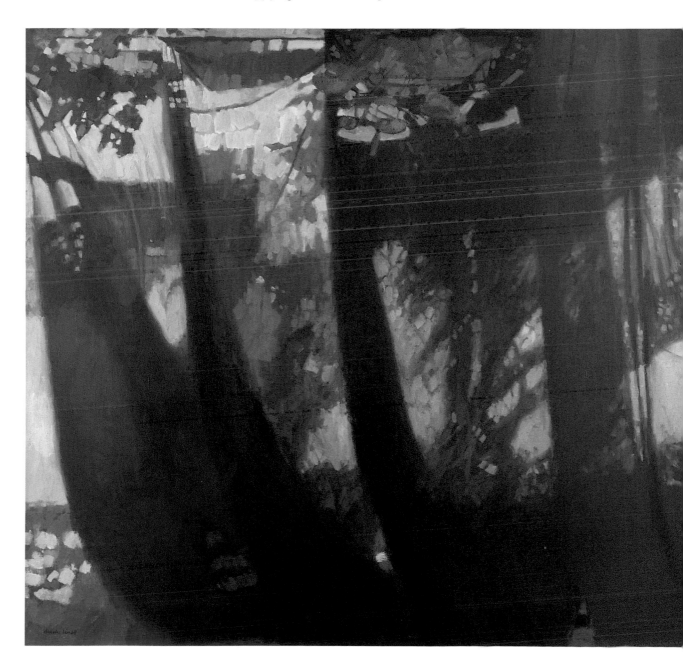

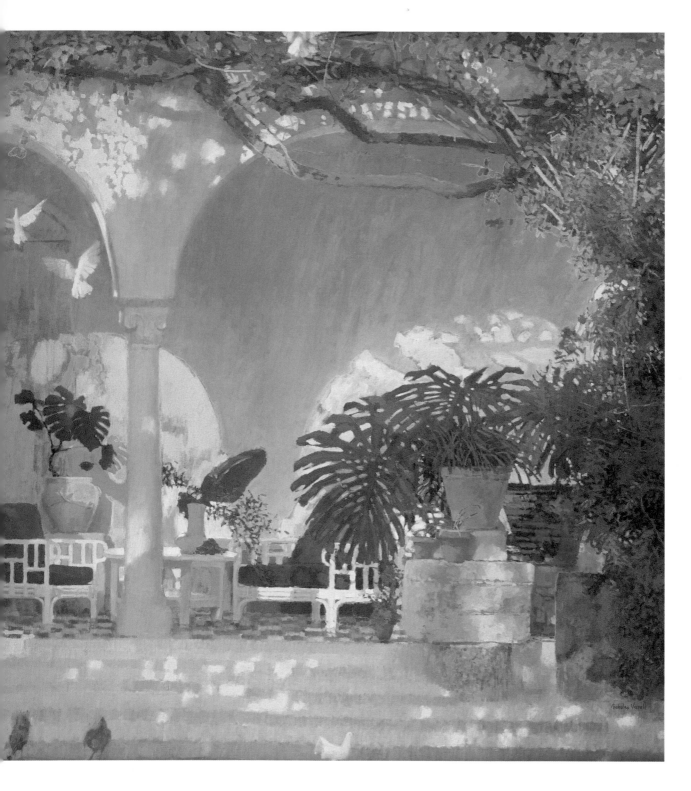

Above: **30. The Inner Courtyard**
Oil on canvas 122 x 110.5cm
(48 x 43½in)
A general glaze will help unify the
painting. Here, I have applied a blue
glaze over the initial pink underpainting.

Glazing is a very free way of working; if the colour doesn't look right or it doesn't produce the effect you had anticipated you can easily wipe the paint off with a rag. So there is plenty of scope to experiment and, if necessary, radically alter the character and mood of a picture. Sometimes, when I am unhappy with a painting or feel it needs enhancing in some way I apply an overall glaze, let this dry, and then work back into the painting to re-establish the particular direction and quality that I'm after.

Brushwork Effects

By using different types of brush and varying the paint consistency it is possible to create a huge range of brushwork effects. Equally, applying colour wet-over-dry or wet-into-wet, as well as altering the direction and character of the brushstrokes, will contribute to such effects. You can exploit different brushwork effects to help describe and define objects, to suggest textures, to create rhythm, movement, depth and similar qualities, and to convey your thoughts and feelings about a subject in a personal manner.

My style of working essentially involves building up areas of colour with a sequence of brushstrokes and in most paintings I like to contrast obvious brushstroke effects with flatter, more restful passages, adding to the interest of the painting. The brushwork can be particularly important in a foreground area, to enliven what might otherwise be quite a dull space. Note how I have painted the foreground grasses in *Fontaines Provençales* (see below), for example. Also in this painting I have used a pointillist brushwork technique (small dots of colour) to convey the impression of the sparkling light on the water. This is a useful technique, but one that must be applied with the awareness that, without some care, the dots of colour can easily appear monotonous and mechanical.

*Below: **31. Fontaines Provençales***
Oil on canvas 98 x 137cm (38½ x 54in)
A pointillist technique – building up areas with small dabs of colour – is ideal for suggesting water and spray effects.

Scumbling

Scumbling is an excellent technique for capturing atmospheric qualities and diffused lighting effects, particularly in landscape subjects. It involves working a thin layer of dry, semi-opaque colour over a dry underlayer, so that some of the original colour shows through. This gives a lively, shimmering paint surface. I have used this technique for the 'lost and found', misty background effect in *Chinese Bridge, Early Morning* (see below) and also for the background in *Moored Boats* (see below), which was built up with a sequence of dragged, superimposed brushstrokes, rather like the way I work in pastel.

The paint used for scumbling should be relatively dry and free of any additional oil. Some artists use paint straight from the tube and begin by squeezing it out onto some newspaper, which soaks up some of the oil. Equally good, I find, is paint that has been left on the palette for a day or two and has partially dried out. If thinner and more liquid paint is used, then you should be careful not to overload the brush. Alternatively, before applying the colour, wipe the brush with a piece of rag to remove most of the paint.

Use a bristle brush and drag the paint across the surface, holding the brush in an almost horizontal position. Scumbles can also be applied with the brush held vertically, in a sort of circular motion, and with your finger, a rag or a sponge. They are most effective over a coarse canvas or board surface, where they accentuate the texture.

Below: **33. Moored Boats**
*Oil on canvas 122 x 132cm (48 x 52in)
In this painting the whole of the background area is built up with scumbled paint in quite a spontaneous way, with obvious brushstrokes, to suggest the reflections of the clouds in the water.*

Left: **32. Chinese Bridge, Early Morning**
*Oil on canvas 122 x 129.5cm (48 x 51in)
Here I chose a scumbling technique for the background, to create the misty effect. The scumbled paint gives a feeling for the trees without actually depicting lots of leaves.*

Impasto

Paint that is applied thickly, such that the marks and ridges made by the brush or painting knife contribute in a decisive way to the character of the work, is known as impasto. To create this effect you can use colours straight from the tube, build up the texture in layers, or mix the paint with a texture medium such as Oleopasto (Winsor & Newton), which thickens the paint, and will also act as an extender to make your colours go further.

Although I often explore the textural possibilities of brushmarks, I seldom use very thick paint. However, I do like impasto for highlights and similar light effects, which I normally add during the final stages of a painting. In fact this is a fairly traditional way of working, a practice used by Turner, Rembrandt and other well-known artists of the past, and it has the added advantage that you finish with the thickest areas of paint, in the accepted 'fat-over-lean' method. As in *Wysteria and Pots* (see below), I sometimes work a glaze over the textural areas to unify them with the rest of the picture or enhance the mood or light effect.

I also occasionally build up an impasto effect with thickly-applied layers of colour. I begin with a dull colour and when this is dry I go over it with a stronger colour, perhaps adding further layers if necessary. This produces a texture and colour with more depth and interest than one that has been applied as a single, very thick layer. Impasto is a particularly good technique to try if you are concerned that your work is too fussy, because it will force you to adopt a broader, looser approach.

Below 34. Wysteria and Pots
Oil on board 27 x 35.5cm (10³/₄ x 14in)
Board absorbs the oil from the paint quite quickly, which is particularly helpful for building up textural highlights.

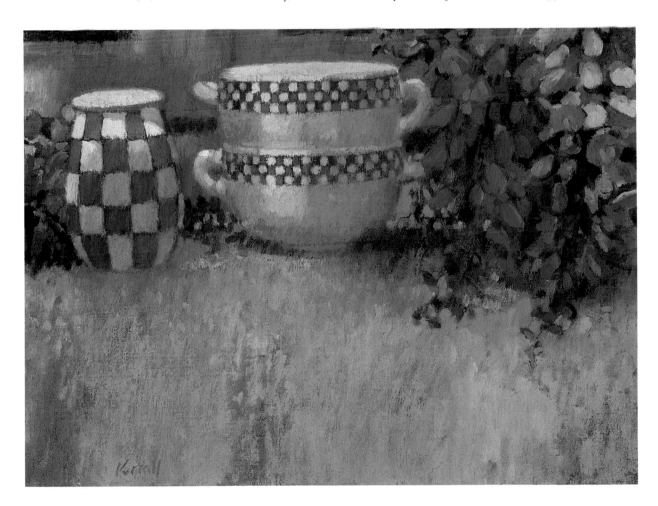

Left: **35. The Glasshouse**
*Oil on canvas 142.5 x 122cm (56 x 48in)
Appropriate textures for different
subjects and surfaces can be created by
varying the marks and strokes made with
the brush.*

Alla Prima

The term *alla prima* is used to describe paintings that are made swiftly and directly
in a single session of work – usually just two or three hours – and which therefore
involve a 'one-wet' technique. This means that the colour must be applied straight
away as 'finished' colour, because it cannot be built up in layers over a period of
time. Indeed, the lack of drying time prevents complicated procedures and instead
encourages a spontaneous, intensive approach.

Alla prima is an ideal technique for landscape subjects, where in any case the light is
usually dramatically different after a couple of hours or so, and it also suits those
subjects, such as *Petit Garçon sur la Terrasse* (see page 107), that will not stay put for
very long! Because of the time constraints, it is usually best to work on a small
scale, say 25 x 35.5cm (10 x 14in), perhaps on canvas or board that has been
prepared with a coloured ground.

As explained on page 20, I normally prepare small painting boards in this way. I
prefer to use boards when working at this scale because they are more absorbent.
This means that the paint dries quicker and so allows more scope for different
techniques. I still begin with an underpainting, in order to place the main shapes
roughly and get a feel for the subject. If thin paint is used, the underpainting tends
to sink into the board and dries very quickly. Then I put in the darks, wiping the
paint off where I want the lightest areas, and I gradually develop the painting with
thicker paint.

Varnishing

As most oil paintings are not framed under glass, they are usually varnished to protect the surface from dust and other damage. Another advantage of varnishing is that it will 'lift' those colours that have dried in an uneven or dull way and give the whole painting a uniform degree of matt or gloss finish, depending on which type of varnish is chosen. Paintings must be completely dry before they are varnished and this may take up to eight months, perhaps even longer if really thick paint has been used.

Most picture varnishes today are soluble in turpentine. This means that in the course of time you can clean the painting by removing the varnish, and with it the surface dust and dirt, without damaging the oil paint underneath.

Right: **36. L'Escalier Blanc**
Oil on canvas 89 x 61cm (35 x 24in)
Most paintings rely on a variety of techniques, although one technique might be used more systematically than the others in order to create the drama and impact required. Here, I have used blending and glazing for the background and shadow areas, impasto for the highlights, and various brushwork effects for the flowers and foliage.

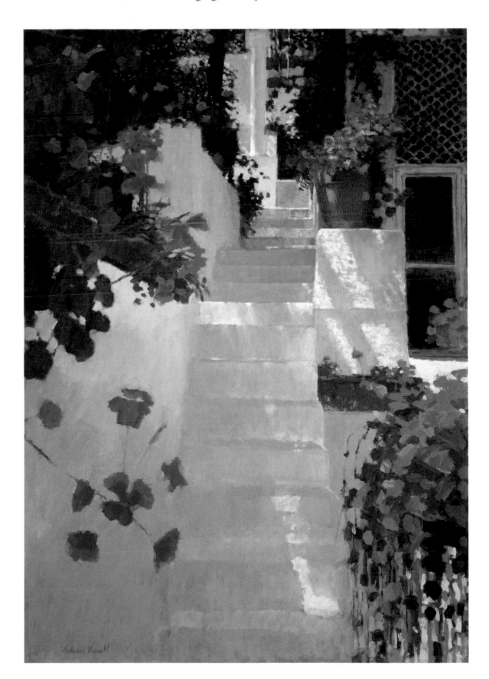

Capturing Colour and Light

In most of my paintings the essential quality that I want to capture is the feeling of a particular kind of light at a certain time of day. To create this effect I rely principally on a harmony of colours rather than on special techniques, although naturally the way that each colour is applied plays an important part. By looking at the groups of colours that make up the subject, and adjusting these colours as necessary to emphasize the light effect and mood that I want to convey, I try to suggest the feeling of, for example, a warm evening, a bright, sunlit afternoon or a misty dawn.

Expressing what you feel is important about the subject matter, and producing paintings that evoke a particular mood and atmosphere, are skills that depend to a great extent on a knowledge of colour and confidence with colour mixing. These are skills that are acquired gradually, largely through the experience of actually mixing and applying colours and noticing how they interact. But equally, as discussed in the following pages, there are various processes and theories that can help guide you along the way, and other factors that have an influence and that you should be aware of.

With colour, as with all aspects of painting, it is a matter of developing a broad base of knowledge so that, in time, you can channel this to suit your own aims and objectives in your work. The response to colour is a very personal thing and, as I know from my own paintings, the greater your experience of handling colour, the more ambitious and intuitive you can be in your approach.

*Right: **37. Evening in the Meadow***
Oil on canvas 123 x 129.5cm (48½ x 51in)

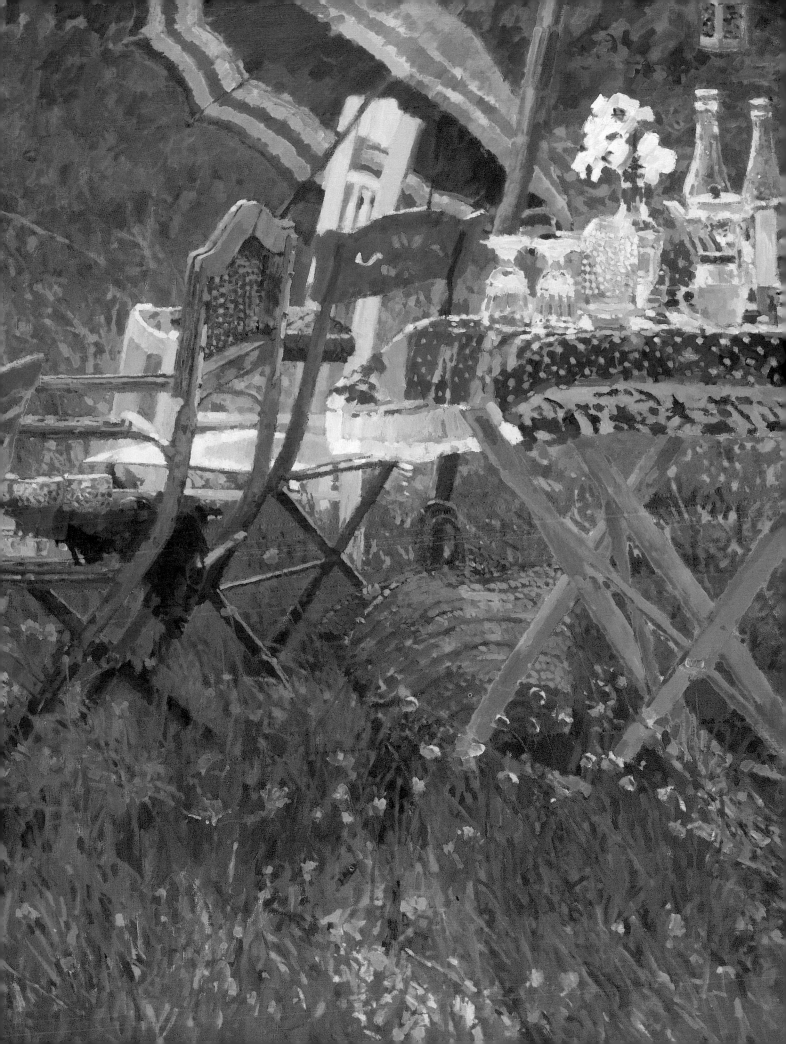

Observing Colour

Before attempting to interpret the distinctive qualities of light and mood in a subject it is always a good idea to spend some time just looking and assessing which aspects and colours you should concentrate on. Observation is important: not necessarily to notice the actual colours, but how each colour relates to everything else. Also, try to develop a way of looking at objects without preconceived ideas about which colours they should be. For instance, is an area of grass simply green? Usually, a closer analysis shows that what appears to be one colour is actually a combination of various, more subtle hues.

Local Colour

The 'local colour' of an object is its true, basic colour in full daylight, unaffected by such factors as shadows, reflected colours from surrounding objects, and so on. Generally this is the aspect of colour that you notice first. It provides an indicator as to the colour key of the subject – whether it is high key (bright colours and light tones) or low key (dark colours and tones). Then, as explained above, you can qualify this first impression by studying exactly what happens in terms of tonal variations and colour interactions.

However, in practice it is pointless to consider each colour as a separate entity. The impact of a painting is determined by the collective effect of the colours: the way they all work together to express a certain feeling. So a vital part of the painting process involves adjusting colours to create the right relationships. But where do you start? In my paintings I usually choose the area that I consider the most significant in terms of evoking the quality of light and sense of mood that I want. Having blocked in the main shapes of the composition I start with that key area. If I can get that right then I know I will gradually succeed in building the necessary colour harmonies around it.

Left: **38. Hill Town, Provence**
(Stage 1)
Oil on Canvas 107 x 96cm (42 x 38in)
I always keep the initial colours quite subdued. This allows me the freedom to develop a degree of intensity with the colour later on.

Right: **39. Hill Town, Provence**
(Stage 2)
Oil on Canvas 107 x 96cm (42 x 38in)
In the final painting I have used a heavy impasto of rich colours, enhancing the harmony of oranges and yellows, and thus creating a feeling of warmth and sunlight.

Nevertheless, although a colour may look perfect when you initially apply it, you have to be aware that at some subsequent stage you may need to adjust it. Painting is never just a matter of getting one colour right, moving on to the next one and getting that right, and so on. That method inevitably leads to a whole succession of colours that, together, are wrong! Instead, you have to look and alter, look and alter, all the while working towards your intended aims and effects. Every colour in the painting affects the overall impression a viewer has of every other colour in the painting.

It's rather like music. If you can strike the exact notes of the colours you need, then together they will create the feeling of the particular day and place you have in mind. In *Evening in the Garden* (see opposite), for example, I have tried to find precisely the right colour relationships to convey the light and mood at that time of day.

Colour and Mood

When I come across a subject that interests and inspires me, rather than suppose that I must paint it exactly as I see it, I like to make a more personal response. This is surely the purpose of painting: to express our individual thoughts and feelings about something. Also, of course, we should be sensitive to the fact that we are interpreting an idea through the medium of paint, and consequently we must respect and respond to its characteristics, possibilities and limitations.

The quality that usually attracts me to a subject is the light, and something that particularly interests me is how the light creates a distinctive ambience and mood throughout the scene. It is this aspect of the subject that I find most challenging and rewarding. As the impact and subtleties of light can only be interpreted through tones of colour, always the greatest challenge is to find those colour harmonies that will conjure up the right atmosphere and sense of place.

When selecting colours, in order to express the mood of the painting with some impact, I generally find it helpful to exaggerate the colour contrasts and relationships that will contribute to the intended effect, while perhaps understating or even ignoring others. With reference to my preliminary drawings and location photographs, which help me recall the scene, the time of day and my feelings about the subject, I consider the palette of colours that will be most suitable. As in *The Fruit Stall, Paris* (see below), in which I have tried to capture the dusty atmosphere of this Parisian backstreet, I often keep to quite a limited range of colours.

Left: **40. The Fruit Stall, Paris**
Oil on board 43 x 51cm (17 x 20in)
What attracted me to this subject was the bright colour of the fruit in contrast to the surrounding greys and browns.

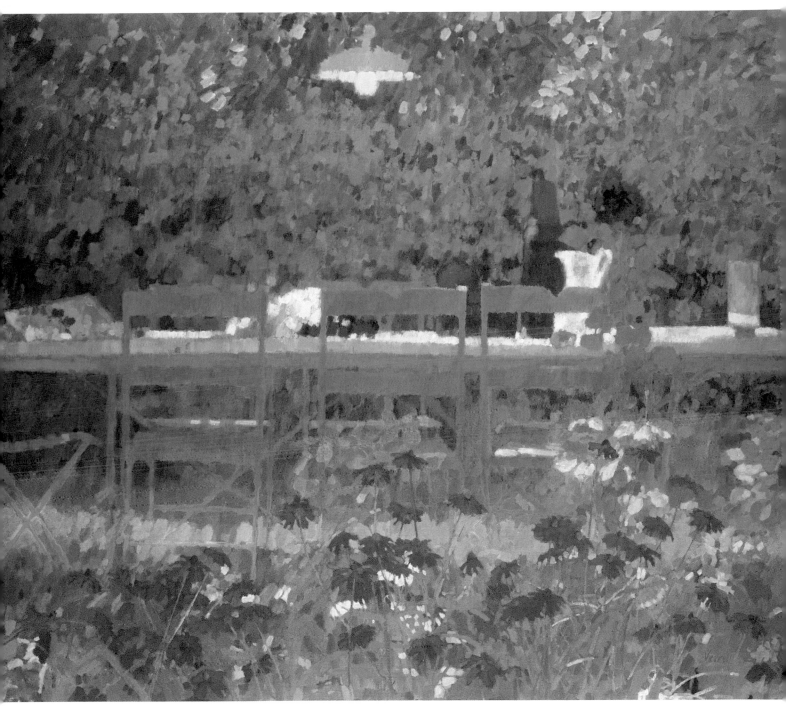

Above: **41. Evening in the Garden**
Oil on canvas 101.5 x 119.5cm (40 x 47in)
I felt that the horizontal bands of colour,
which seemed to echo themselves either
side of the central table, made a very
exciting feature in this scene.

Colour as a Subject

Colour is an important quality in every subject and, as I have explained, it is vital to observe and understand what is happening in terms of colour in order to interpret the effects of light and mood convincingly. But colour can be more than simply the means by which we create certain effects. It can be the principal reason for making a painting. There are some subjects in which the colour itself is the most powerful attribute. This is a feature that can be exploited, thus creating a composition whose impact relies chiefly on the intensity, contrast and placing of different colours.

Occasionally it is also worth deliberately setting yourself a challenge with colour. Try some paintings in which you experiment with colour combinations and harmonies that you haven't used before. The reason I suggest this is that it will encourage greater breadth and development in your work and it will help prevent repetition. Most artists keep to a certain range of colours, and while this has many advantages, equally there can be a temptation to rely on well-proven colour mixes and harmonies. If these mixes and harmonies begin to appear in every painting, then their impact is diminished. I like to set myself a problem of this kind now and again, perhaps trying a painting that is restricted to a range of yellows, for example, or in which there is an unusual combination of colours.

Above: **42. Autumn in Provence**
Oil on board 30.5 x 43cm (12 x 17in)
The rich, warm colour of the building, as a backdrop for the tree with the last of its golden leaves, created a strong feeling of autumn.

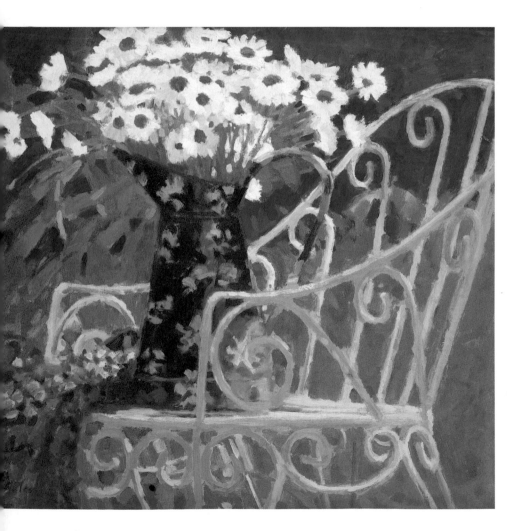

Left: **43. The Red Enamelled Jug**
Oil on board 33 x 33cm (13 x 13in)
I liked the idea of the red jug encircled by the chair, and I thought it would make an interesting composition.

Suggesting Space and Depth with Colour

As well as its use to express and describe things, colour can also play an important role in suggesting space and distance in a painting. In this context colour is usually considered in relation to other factors, such as the handling of tone, texture, detail and relative scale, but its exact role and significance will depend on your particular style of work.

If you like to paint in a representational way, then you may find it helpful to study some of the theories and techniques relating to colour and distance. For instance, vibrant, high key colour will tend to attract attention and come forward in a painting, suggesting proximity, whereas paler, subdued colours will recede, suggesting distance. This being so, objects in the background will generally look cooler in hue and weaker in tone than those close to you. Also, with foreground objects, there is usually quite a lot of variation in the colours and tones, whereas in the distance such contrasts are softened, giving a more uniform tonal quality. In landscape subjects, far-off hills and other features often appear to have a bluish hue, due to atmospheric haze. This effect, known as aerial perspective, is again something that can be exploited to give an impression of space and depth.

*Below: **44. Evening, Tuscany***
Oil on canvas 95 x 131cm (37½ x 51½in)
Here, I wanted the colours to suggest the sort of fresh atmosphere that you find on a late summer's evening after it has rained.

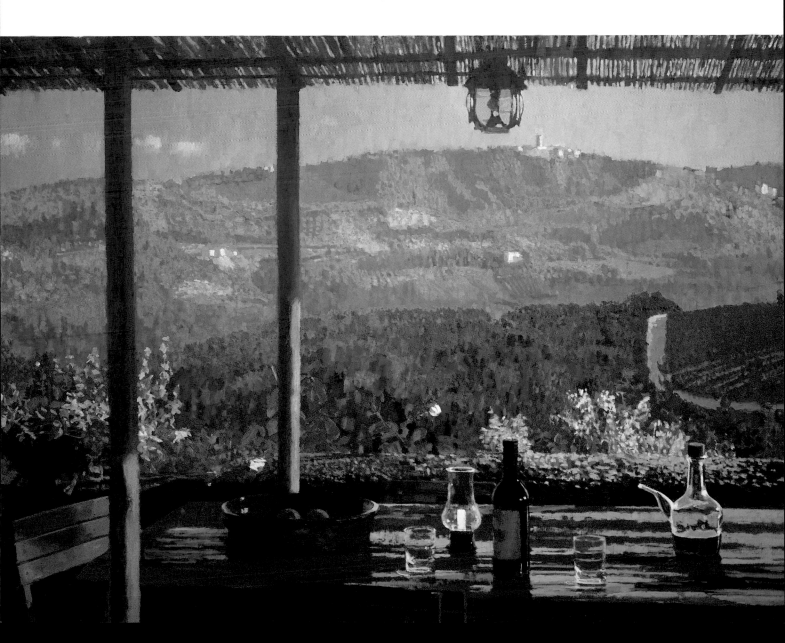

Personally, I use a more intuitive response to achieving a feeling of space and distance. In fact in many of my paintings the spatial quality is not a principal concern. What interests me more is the way that light moves across the subject and the shapes and patterns this produces. But when I do want a positive sense of depth, then I rely on observation rather than theory. I paint the colours that I see and feel, perhaps softening some and emphasizing others to create a more dramatic effect, as in *La Vieille Cage à Oiseaux* (see right).

Light and Colour

Whatever subject you choose to paint, most probably light will be a significant feature and consideration. There are many different types of light of course – soft, dappled, sharp, dramatic and so on – and each of these is capable of radically affecting the appearance and character of a subject, as is the strength and direction of the light. Furthermore, the play of light produces tonal variations within areas of colour, helps define objects, and creates shadows. These are all elements that will contribute to the interest and success of a painting.

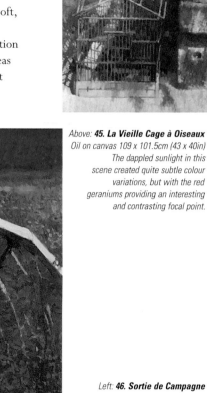

Above: **45. La Vieille Cage à Oiseaux**
Oil on canvas 109 x 101.5cm (43 x 40in)
The dappled sunlight in this scene created quite subtle colour variations, but with the red geraniums providing an interesting and contrasting focal point.

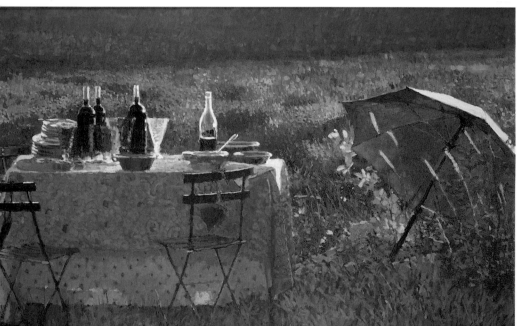

Left: **46. Sortie de Campagne**
Oil on canvas 57 x 91.5cm (22½ x 36in)
Contrasts between deep shadows and glistening highlights will create intense drama in a painting, as here.

The Influence of Light

Essentially, all figurative paintings are concerned with light. It can be the initial inspiration for a work, and invariably it has an influence on a wide range of important factors during the painting process. For instance, the way that we perceive objects, their structure and surface modelling, are aspects that are largely determined by the intensity, direction and quality of light. But above all, it is light that gives a subject its distinct mood and impact.

It follows that to create a convincing sense of place and atmosphere in a painting you must first observe and understand what is happening with the light. Start by checking the source of light, how it plays across the subject and any notable light

Above: ***47. House with Blue Shutters***
Oil on canvas 109 x 122cm (43 x 48in)
Bright sunlight tends to weaken and diffuse colours, producing a kind of shimmering effect. In the foreground of this painting I have tried to suggest the influence of light and heat by using a variety of colours but keeping them to more or less the same tone.

effects. Are there particular light/dark contrasts that can be exploited, for example, or interesting shadows that could be a feature of the composition? Many artists like to make a small tonal sketch, or sometimes a sequence of sketches, to examine the distribution of the dark, mid-tone and lighter values throughout the subject, and how these will work together to make a strong composition.

As I have mentioned, in my work I am interested in creating a flow of light across the picture surface, and to achieve this I am constantly adjusting colours and moving them around so that the feeling of light runs throughout the painting. I like the idea of light bouncing off some objects, diffusing others, making bold shadows and so on. Light can hold the picture together and also create movement and mood, both of which add to the interest and excitement of the painting. In *Still Life with Decoy Duck* (see page 50), the light streaming in from the left-hand side produces a slightly mysterious quality in the shadows and, in contrast, makes various objects come alive where it touches them directly.

Tonal Values

In addition to their intrinsic hue, colours also have a tonal quality, that is a relative value of lightness or darkness. Consequently, during the course of a painting, at the same time as selecting each colour, you need to estimate its tonal value – how light or dark it is in relation to everything else. The ability to see objects in terms of tone as well as colour will enable you to interpret them more successfully, for it is principally the variations of tone in a painting that help convey aspects such as three-dimensional form, space and atmosphere.

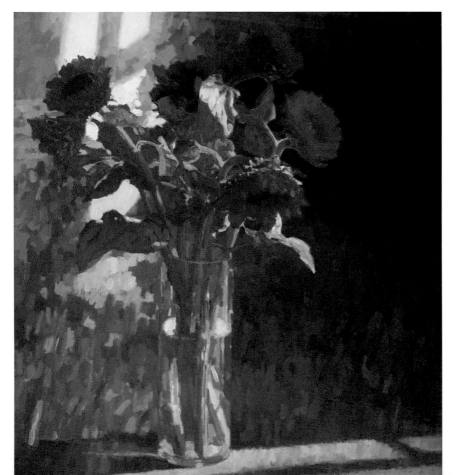

The main factor in determining tonal variations is, of course, the strength or weakness of the light. So, in order to capture the feeling of a particular time of day, type of weather or quality of light, the first essential is to consider the tonal range and relationships in your subject. When you first start painting, judging light and dark values is quite difficult, but it soon becomes second nature. A helpful technique in estimating tones is to try to imagine the subject as a black-and-white picture. If you half close your eyes as you look at the subject, this will help enhance your perception of tone, rather than colour, and it also gives a more general, simplified view of the tonal distribution. As suggested earlier, you may also find it useful to make a small pencil or charcoal sketch that concentrates on the general lights and darks.

I quite often begin with a tonal drawing. This helps me assess a number of key aspects of the subject. For instance, the tonal contrasts and harmonies can contribute in a very positive way to the composition – they make an important contribution to the sense of dynamism and movement in a painting. Then, once I am happy with the tonal balance, I start to think about colour. However, in most of my paintings the greatest challenge is creating the right interactions between light areas and shadows.

Tone and Colour

There are two ways in which tone can relate to colour: every colour that you lay out on your palette has an inherent tone; and, additionally, each of these colours can be modified (by the addition of diluents or mediums, or by mixing them with other colours) to create a range of lighter or darker values. You will notice that the inherent tone of orange and lemon yellow, for example, is essentially light; red and green come in the mid-tone range; and purple and Winsor blue are both naturally dark colours.

*Right: **50. Le Soleil du Midi***
Oil on canvas 99 x 122cm (39 x 48in)
The foreground in this painting, with its
suggestion of bright, reflected light,
creates the feeling that this is
a hot, sunny day.

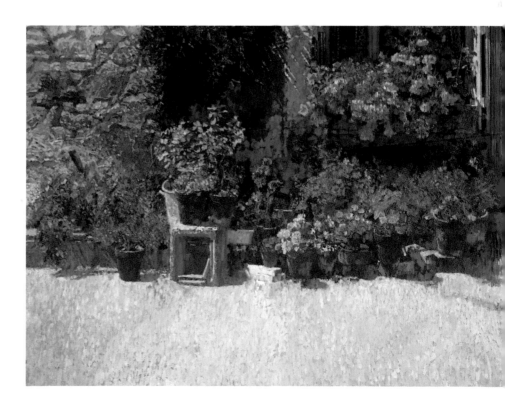

When painting, you could employ both of these possibilities to produce the tonal contrasts and harmonies you need. For example, in some areas you could juxtapose selected palette colours to convey different light and dark effects, such as a yellow against a purple, while in other parts of the painting you could use a range of tones made from one colour. A shadow area, for instance, could be painted with a variety of blue tones made from cobalt blue mixed with white, permanent mauve and other colours. An advantage of this approach is that, being mixed from the same basic colour, the blues have a sense of harmony, despite their differences in tone.

Strong tonal contrasts can be a really interesting feature of a painting. In *The Little Orange Tree* (see right), I have explored this idea, balancing the intensely dark tones on the right-hand side with some very light areas on the opposing side, and using the shadows to unify the whole composition.

Shadows

Shadows are one of the most obvious indicators of the strength, direction and quality of light found in a subject. As such, they are an important feature to consider when interpreting light and atmosphere. They can also contribute in various ways to the overall interest, design and success of a painting. Because I like to paint scenes that have strong contrasts of light and dark – particularly the effects of sunlight – shadows are always an intrinsic and powerful element in my work. Indeed, quite often they are the main point of interest in my paintings.

Above: **51. The Little Orange Tree**
Oil on canvas 109 x 129.5cm (43 x 51in)
Essentially this is a very ordinary scene but it has been transformed into something far more exciting by the influence of light.

Left: **52. Salle Jaune**
Oil on canvas 122 x 139.5cm (48 x 55in)
The challenge here was to balance the shadows and light on the left-hand side of the picture with the various objects on the right.

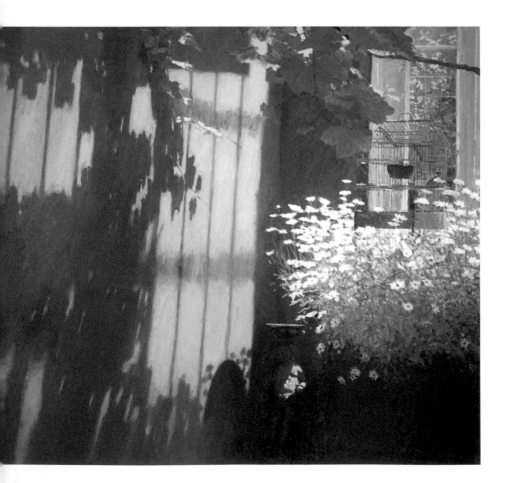

Something that can prove difficult with an outdoor subject is the fact that the shadows do not remain the same for very long: they gradually change as the day progresses. To overcome this problem, try making a tonal sketch to 'fix' the shadows in the position that you want them to be in the actual painting. Alternatively, you could take some reference photographs. By observing the shadows in this way you will also notice their subtleties and variations. Shadows often contain different colours as well as transitional phases of tone, so painting shadows is never simply a matter of adding dark shapes.

I regard shadows as an integral feature of a representational composition, and consequently I am thinking about them right from the start of a painting. Where a shadow falls across something, such as the wall in *The Little Orange Tree* (see opposite), I usually paint the shadow area first and then add the brighter parts. Generally I use glazes and scumbling techniques for the shadows, with much thicker paint for the light areas. Also, I think carefully about the exact colours of the shadows in relation to the rest of the subject – see page 93.

Below: **53. Still Life with Olive Oil Cans**
Oil on canvas 108.5 x 104.5cm
(42³/₄ x 41¹/₄in)
The colour of shadows is always a difficult thing to judge. Very often, the only way to find the right colour is by trial and error – by experimenting with different colours on the canvas.

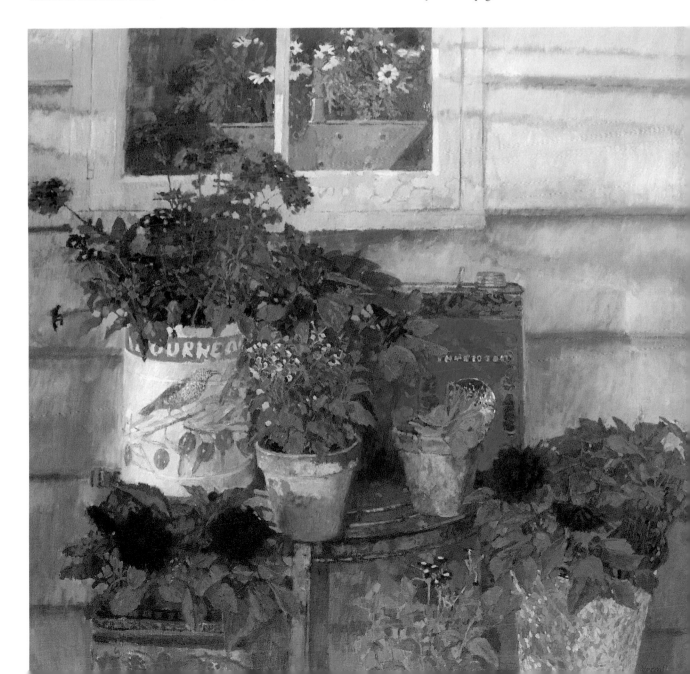

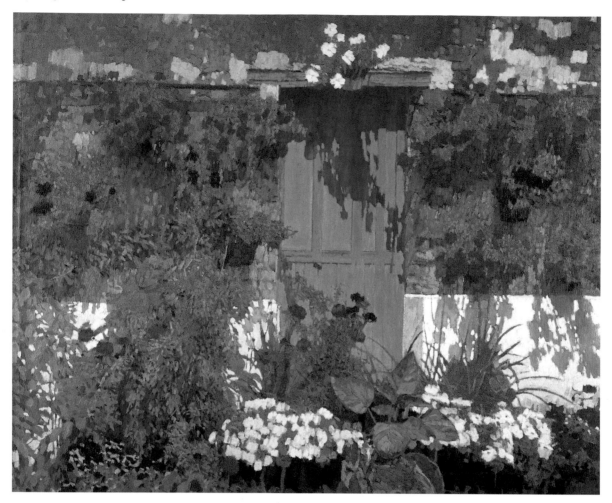

Colour Harmony and Contrasts

The overall effect that a painting conveys is largely dependent on the choice of colours and how the different colour masses and intensities interact and work together across the picture surface. Most paintings rely on a basic harmony in the colour selection but with the use of a complementary colour or more dramatic tone here and there to give one or two areas of contrast and focus.

You can create colour harmony by keeping to a restricted number of colours (a limited palette); by working with analogous colours (colours that are next to each other on the colour wheel, such as a sequence from orange-red through to yellow); by confining the painting to a range of one pigment, say blues; or by using paint mixes that contain a common colour. I choose colour schemes according to the lighting and atmosphere in the subject. In *Hanging Baskets* (see above) for example, I wanted to capture the bright, sunlit, staccato feeling of the colour. To express that quality I had to ensure that all the colours, including those of the shadows, worked with the right balance and contrast.

Colour Interactions

Naturally each subject will require a different colour scheme and technical approach to suit the particular sensation of light, colour and mood that has to be expressed. So, before beginning any painting I think about how I am going to interpret its specific, individual qualities and what the likely technical problems will be. I ask myself what it is about this image that makes it different from other

Above: ***54. Hanging Baskets***
Oil on canvas 82 x 99.5cm (32¼ x 39¾in)
This was a difficult subject to attempt because it involved almost all the colours on the palette. Success depended on creating the right balance of colours and tones.

images. And I look for the dominant colour, the key area of interest around which to develop the whole painting. With *Morning Glory* (see below), for instance, I knew that the most important aspect to concentrate on initially was the tonal and colour contrast between the bright reds and blues in the background.

From this kind of starting point I begin to explore and evolve the colour harmonies and interactions. As mentioned before, once the painting is in progress each additional colour will influence and be influenced by those colours already in place. This means that colours may have to be adjusted and readjusted as the painting develops, until the correct colour relationships are achieved. Working in this way, I place one colour against another and exploit as fully as I can the potential for different colour harmonies.

Right: **55. Morning Glory**
Oil on canvas 108 x 129.5cm (42½ x 51in)
In this painting I was mostly interested in the flat pattern effect of colour, although there is an indication of space (in the line of the roof, the doorway, and so on), if the viewer wants to read it as such.

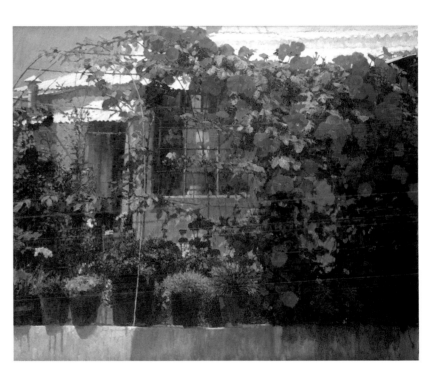

Right: **56. The Dresser**
Oil on canvas 61 x 61cm (24 x 24in)
Given the influence of light, it is surprising just how much variation of colour there can be in a subject which, at first glance, seems predominantly one colour.

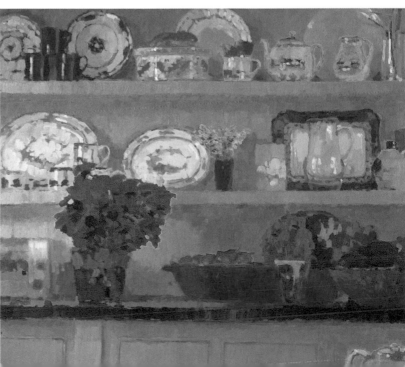

For one subject I may need a harmony of rich colours, for another a more mellow harmony, and so on. There is no restriction as to the sort of harmonies and contrasts that can be used, providing you can make them work! Essentially my aim is to interpret the light effect seen and experienced in reality with carefully judged colour harmonies that produce the same feeling in the viewer. To do this successfully, sometimes it is necessary to exaggerate the contrasts and harmonies, while on other occasions it helps to subdue one of the main colours so that the others will work more harmoniously. Look at *Sunflowers and Marigolds* below, for example, where I have deliberately reduced the intensity of the background greens in order to create a better harmony with the various orange colours in the flowers.

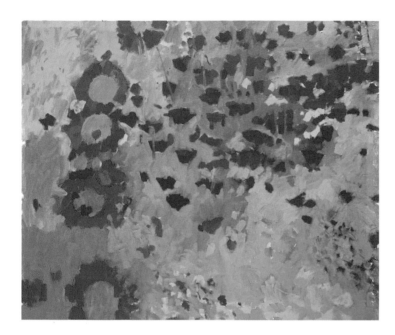

Colour and Composition

In addition to its descriptive and expressive qualities, colour also plays its part in reinforcing the structure and impact of the composition. The placing and intensity of the different colours is often a significant element in suggesting movement around the picture and directing attention to certain areas or features. If a painting includes a dominant area of yellow, for example, that particular colour can be hinted at in various other parts of the picture, contributing to the sense of unity, balance and movement. This happens in *Deckchairs* (see opposite), where the yellow that appears in the windbreak and the deckchair on the right is echoed in the upper part of the composition, so linking the figure with the rest of the painting.

Colour can also be used to give emphasis within the composition – to depict certain qualities and features in a more positive way. The handling of colour, and the degree of contrast and definition between foreground and background areas, are other factors that have to be considered when trying to capture a particular mood or quality of light. You may need to soften the contrast between near and distant colours, for instance, or make the background colour stronger. Remember too that colour can add interest and excitement to a scene. You are free to alter the colours that you see in order to match your emotional response to the subject and to express it in your own individual manner.

*Above left: **57. Sunflowers and Marigolds** (Stage 1)*
Oil on canvas 111.5 x 127cm (44 x 50in)
In this early stage of the painting an important consideration was how the colour would reinforce the composition, by directing your eye to a focal point at the top right-hand side.

*Above right: **58. Sunflowers and Marigolds** (Stage 2)*
Oil on canvas 111.5 x 127cm (44 x 50in)
By reducing the contrast in the colour of the sunflowers, I have prevented them becoming too dominant, and so they create a better balance with the group of flowers on the right.

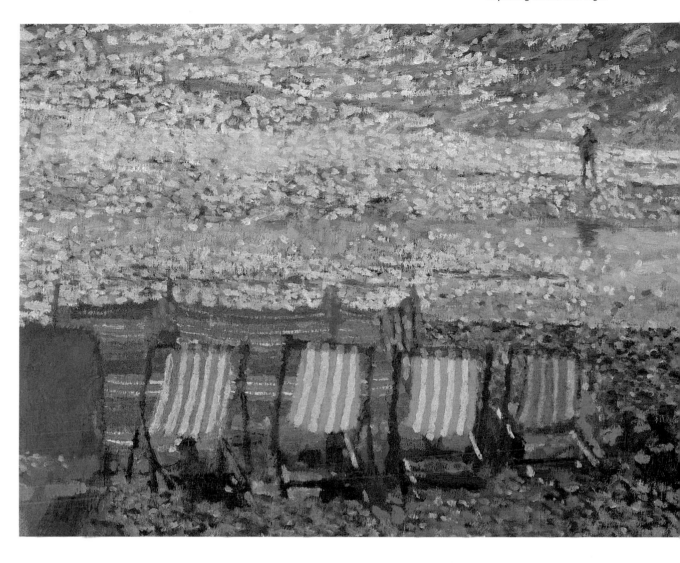

Above: **59. Deckchairs**
Oil on board 38 x 51cm (15 x 20in)
Keeping to a fairly limited palette, I echoed the shimmering effect of the water in the way that I painted the beach, thus emphasizing the mood of the scene. The mauve underpainting creates a further sense of harmony.

Making Colour Work for You

Creating a particular type of light, expressing your feelings about a subject, and capturing the mood of a scene and its sense of place are all aspects of the painting process that depend primarily on the correct choice and use of colour. If the colours are wrong, or they are applied in an insensitive way, then the painting will fail to evoke the feeling you had in mind. So initially, having decided on how you want to interpret the subject, the two most important points to consider are the colour key, or 'temperature' (for instance, whether to use warm, bright colours or cool, subdued ones) and, depending on that decision, the most appropriate palette of colours to work with.

To help in judging which colours will work best, and also as a means of sorting out the composition, it is a good idea to make a preliminary colour sketch. From my own experience I can recommend pastel for this purpose and I have also worked in oils on card. This kind of sketch provides a handy reference throughout the painting process as to the general choice of colours and the required harmonies and contrasts. Something else I would recommend is that if the painting does not succeed as well as you would wish, then try a second version. The best way to learn about colour is to experiment with it and gain as much experience in handling it as possible. Remember too that whatever the subject, you should not be afraid to use colour in a confident and striking way.

Colour Underpainting

When I begin an oil painting I am very aware that the underpainting, or first stage
of colour, will have a significant influence on any colours that are eventually
applied over it. As in *The House with Decorated Walls* (see opposite), I like to build up
the colours gradually, so increasing their intensity and developing the necessary
harmonies and relationships as the painting progresses. For me, the underpainting
is a vital part of this process and when painting it I usually choose colours that
contrast with the actual colours. This gives me greater scope with the subsequent
colours. In *The House with Decorated Walls*, for example, I began with a tonal, purple
underpainting.

You will gather from this that when starting a painting you need to have a clear
vision of your aims and objectives. You need to have the end in mind, as well as the
beginning. Of course, you needn't adopt my colour underpainting approach.
Instead, you could begin with a traditional, monochrome underpainting, or
perhaps you might prefer to work *alla prima* (see page 38), directly onto a white,
prepared canvas or board.

Below: **60. Skiffs in Evening Light**
*Oil on canvas 91.5 x 106.5cm (36 x 42in)
I liked the fact that this subject had an
almost abstract quality. The warm colour
was actually reflected from a wall above.*

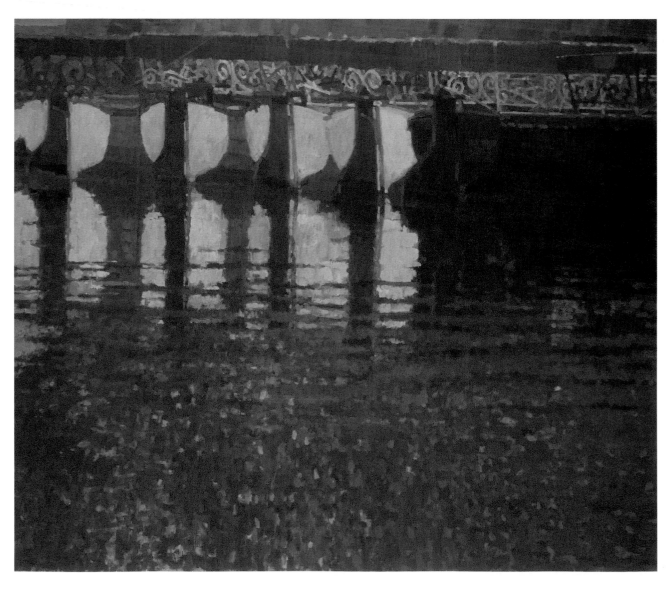

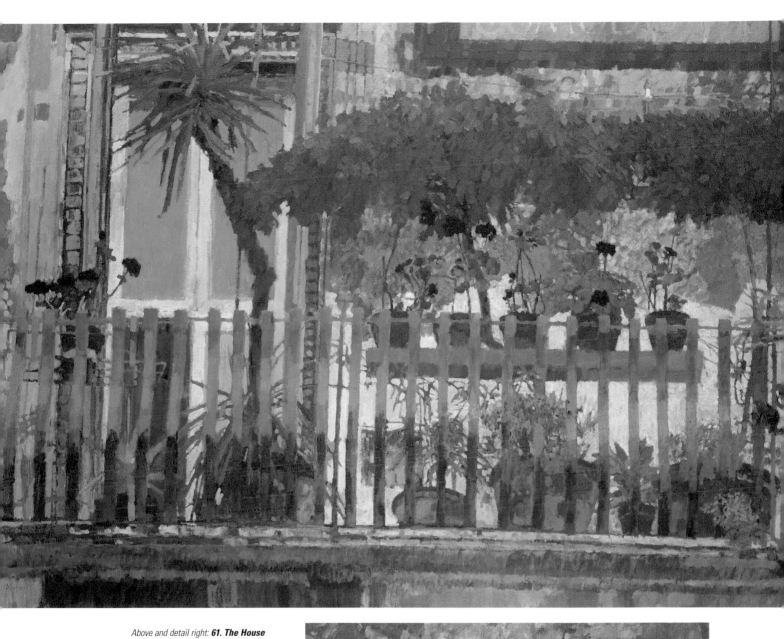

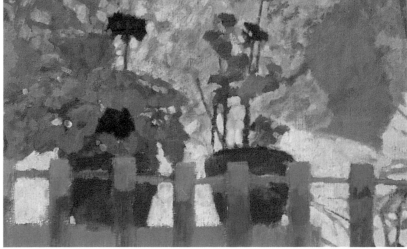

Above and detail right: ***61. The House***
with Decorated Walls
Oil on canvas 89 x 127cm (35 x 50in)
Here, I have tried to harmonize the effect
by brightening the colour of the window,
to make it a more intense purple so that
it complements the green of the trees.

Mixing Colours

Because the exact choice and interaction of the various colours that make up a painting is so significant in achieving the right mood and impact, it follows that the ability to mix colours accurately is one of the most important skills for any artist. As with everything else in painting, this is a skill that develops through practice, as you become more familiar with different colours and the range of mixes they can produce. Eventually, colour mixing becomes a natural, intuitive process, but initially there are some useful facts and theories that can help, and these are discussed below.

When mixing a particular colour remember that you won't necessarily want an identical copy of the colour as it appears in the scene or subject before you. Other factors play a part. You may need to exaggerate or subdue the colour, for instance, to produce a particular effect or, if you are applying it over a previous colour, you will need to assess how this will influence the result.

Even if you are aiming for a strictly representational painting it is seldom just a matter of matching colours. For, as we have seen, every colour interacts with those around it. While a colour may look right when mixed on the palette, it can seem quite different when placed in the context of the painting. When mixing a colour, therefore, you have to take into account any other factors that may influence its hue, intensity and general characteristics.

*Below: **62. Cerisiers dans le Jardin** (Stage 1)*
Oil on canvas 62 x 94cm (24½ x 37in)
Unusually in this painting, tempted by the colourful subject matter, I mixed quite rich colours for the underpainting.

Right: **63. Cerisiers dans le Jardin**
(Stage 2)
Oil on canvas 62 x 94cm (24½ x 37in)
*I applied a purple glaze over the whole
canvas to tone everything down, and
then I worked further on the paintings to
enhance the colour relationships.*

Below: **64. Cerisiers dans le Jardin**
(Completed painting)
Oil on canvas 62 x 94cm (24½ x 37in)
*By underpainting some of the green
areas in purple, and using quite a lot of
red (the complementary colour
for green) in the foreground area, I have
managed to prevent the greens from
becoming too intense.*

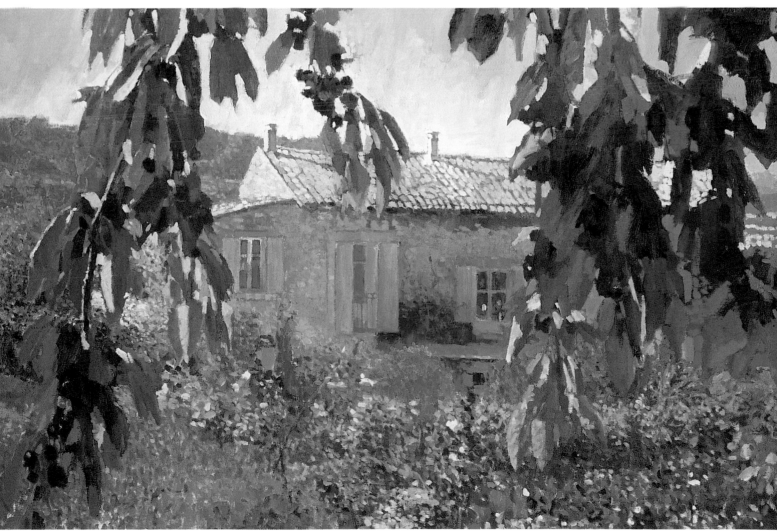

Exploring Colour Theory

Initially, to gain some confidence with mixing colours, you could try combining experimentation and practice with a study of basic colour theory. This will help you understand what will happen when you mix certain colours on the palette. However, while the theory is always helpful, it should never be applied too rigorously to the actual process of painting; there has to be scope for a personal, intuitive response. If the colour mixing becomes too methodical, every picture begins to look the same.

A simple and effective reference for colour mixing is the colour wheel. This is something that you can easily make yourself and it will prove a handy studio accessory. The colour wheel contains the three types of colour that you will most frequently want to include in your paintings: primary colours; secondary colours; and analogous (or harmonious) colours.

The three primary colours are red, yellow and blue and, in theory, all other colours except black and white can be created from these. However, in manufactured paints pure primaries do not exist and so, in practice, it is not possible to mix every conceivable colour totally accurately, although we can get very near. From the palette of 15 colours that I use, the three colours that work best as primaries are cadmium red, cadmium yellow and French ultramarine.

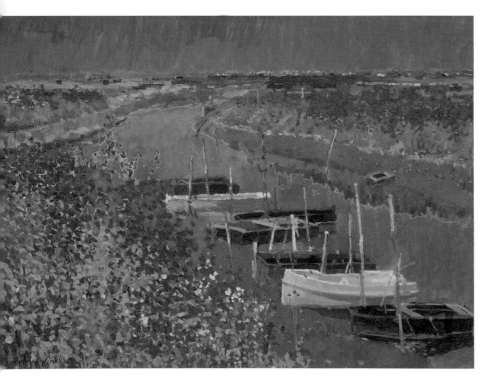

Above: **65. Fields near Arles**
Oil on canvas 43 x 58cm (17 x 23in)
I found this subject in an area where Van Gogh used to paint and in the subsequent picture I tried to reflect some of the colour qualities that I have always admired in his work.

Above: **66. Beach Tents, Normandy**
Oil on board 28 x 51cm (11 x 20in)
Consisting of a simple pattern of
colours, this was an ideal subject
for a location painting.

If you mix one primary colour with another you make what is known as a secondary colour. Thus, orange, purple and green are secondary colours (red and yellow make orange; red and blue make purple; and yellow and blue make green). Naturally, the type of orange, purple or green depends on how much of each of the primary colours you use in the mix. A touch of red mixed with a lot of yellow, for example, will give a weak orange-yellow, whereas a small dab of yellow added to a generous amount of red will produce a vibrant red-orange.

You can make a colour wheel by taking a circular piece of card and dividing it into 12 equal segments. Paint onto the wheel the three primary colours, positioned at intervals of one-third around the wheel, and then the three secondary colours half-way between their respective primaries. The remaining spaces should be filled with colours which are a mixture of the primary and secondary colour on either side of them. For example, between yellow and green comes yellow-green and between yellow and orange comes yellow-orange.

Colours that are next to each other on the colour wheel are called analogous (or harmonious) colours, while those on opposite sides of the wheel are known as complementary colours. Hence you can use the colour wheel to help you identify and select colour combinations for your painting.

Selecting a Palette

You can appreciate, from the colour theory discussed above, that in order to mix a satisfactory range of colours your palette must include at least a red, a blue and a yellow, plus one or two earth colours (such as raw sienna and burnt umber) and white. In fact, most artists include an alternative for each of the primary colours, for instance lemon yellow, alizarin crimson, and cerulean blue, as an alternative range to cadmium yellow, cadmium red, and French ultramarine. This range of substitute primaries greatly increases your options when mixing colours.

I use a palette of 15 colours (see page 22) and I arrange these colours in sequence, starting with yellow, as they appear in the colour wheel. Except for titanium white, which I always need quite a lot of, I usually begin with small amounts of the whole range of colours and then, according to the subject and the way the painting is progressing, I add to these as necessary. I don't think it wise to restrict your palette too much, because this in turn can limit the colour possibilities in the painting.

It is a good idea always to keep the colours arranged on your palette in the same sequence, because then you will always know where to find certain colours and the process becomes quick and automatic. Similarly, by arranging the colours in a colour circle sequence you can readily identify any complementary colours and harmonies that you may want to use.

Mixing Techniques

While colour theory may help you choose the right basic colours for a particular colour mix, creating the precise tone or intensity of colour always involves a certain amount of trial and error. I start by selecting the nearest colour on my palette to the one I want to mix and then I adjust this by adding other colours. If I need an earthy yellow, for example, I might start with some yellow ochre, then add a little viridian and, should the colour still not be quite right, perhaps tone it down with a touch of cadmium red.

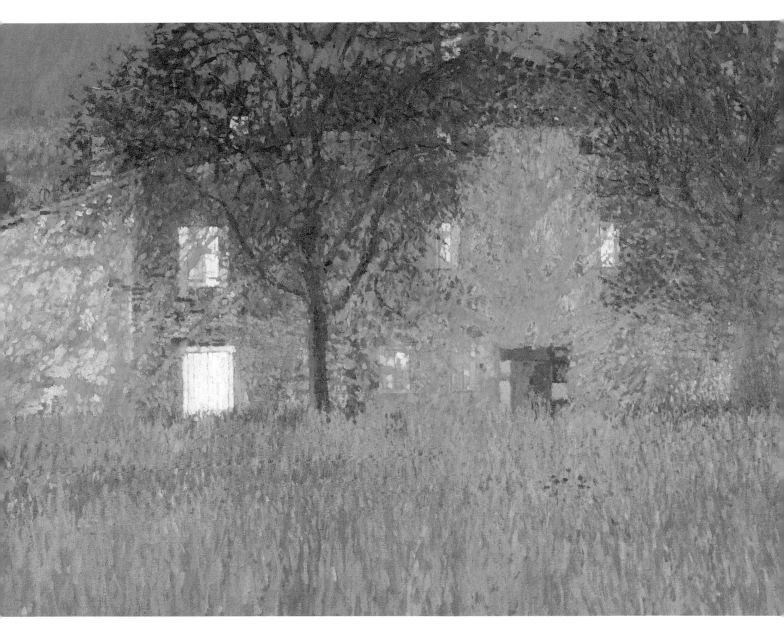

Above: **67. Farmhouse hidden by Trees**
Oil on board 89 x 122cm (35 x 48in)
In the colour mixing for this painting I
decided to reduce the intensity of the
foreground colours so that your eye
would travel back to the area of sunlight
behind, which is where I wanted the
centre of interest.

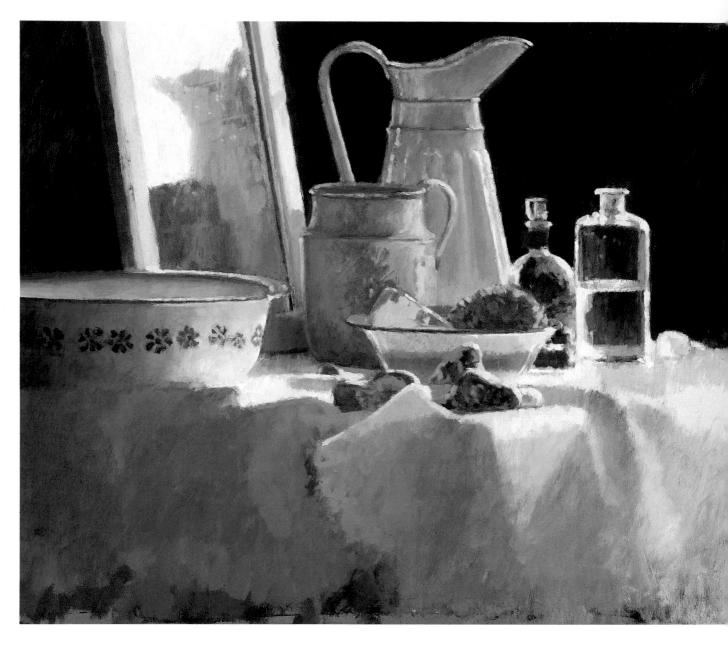

*Above: **68. The Enamel Pitcher***
Oil on board 40.5 x 35.5cm (16 x 14in)
Here, for the striking dark background,
rather than choosing black, I used a
mixture of permanent mauve and raw
umber, which gives a more varied and
interesting dark colour.

I try not to use more than three or four constituent colours to mix a new one. It is difficult to keep the final colour looking pure and fresh if you involve lots of colours in the mixing process. Because I like the paint to be fairly rich and buttery in consistency I only use a small amount of pure turpentine to help thin and mix the colours.

I do not include black in my palette. It is a perfectly legitimate colour (though true black lies outside the range of the colour wheel), but I prefer to make a colour that is close to it by mixing French ultramarine with raw umber. This gives a more vibrant, varied and interesting colour, I think, as demonstrated in the background area of *The Enamel Pitcher* (see above). Another reason to avoid having black on your palette is that it can be very tempting to use it whenever you come across a really dark area in a painting, rather than mixing a colour that is more specific and appropriate.

On the other hand, I use a lot of white. I add white to most colours initially to reduce their intensity, and I also add white when I want to make a colour more opaque. Mixing a colour with white doesn't necessarily make it lighter – it can produce an entirely different colour. Similarly, adding black is not usually the best way to produce a darker colour. If you add black to yellow, for example, the mixture will produce an olive green. Normally, to change the tone of a colour, particularly to darken it, you need to mix it with another colour. For instance, you can lighten a green by adding yellow and darken it by adding blue, and you can tone down any colour by mixing it with its complementary colour (the opposite colour on the colour wheel).

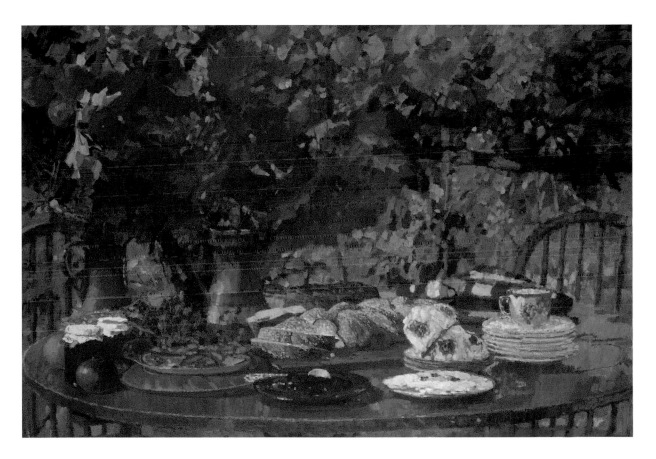

Above: **69. Déjeuner sous les Pommes**
Oil on canvas 79 x 106.5cm (31 x 42in)
A complicated subject such as this will require very considered colour mixes, especially in the final stages of the painting, to create the subtle variations and particular colours required.

Subject Matter

Some artists like to explore particular themes in their work and paint perhaps ten or fifteen pictures related to the same idea. Others, myself included, are motivated by variety. I paint a wide range of subjects, from flowers to figure compositions, and quite often, having worked on one kind of subject matter, I will deliberately start something completely different. For me, this approach, which inevitably involves constantly fresh challenges and demands, adds to my interest in and excitement about painting.

Whatever the subject, I think it is important to consider it without any preconceptions as to how it should be painted. Take a still life, for example. This doesn't have to be a group of objects carefully arranged on a table and then painted in a totally representational way. There are lots of possibilities for creating a composition and interpretation that are quite individual. Similarly, there is no advantage in playing safe all the time and only painting those subjects that you are confident about and that you know will succeed. I make a point of choosing subjects that set me a new problem to solve. I believe this is the way to keep my work lively and forward-looking.

Right: **70. Window onto the Square**
Oil on canvas 114 x 122cm (45 x 48in)

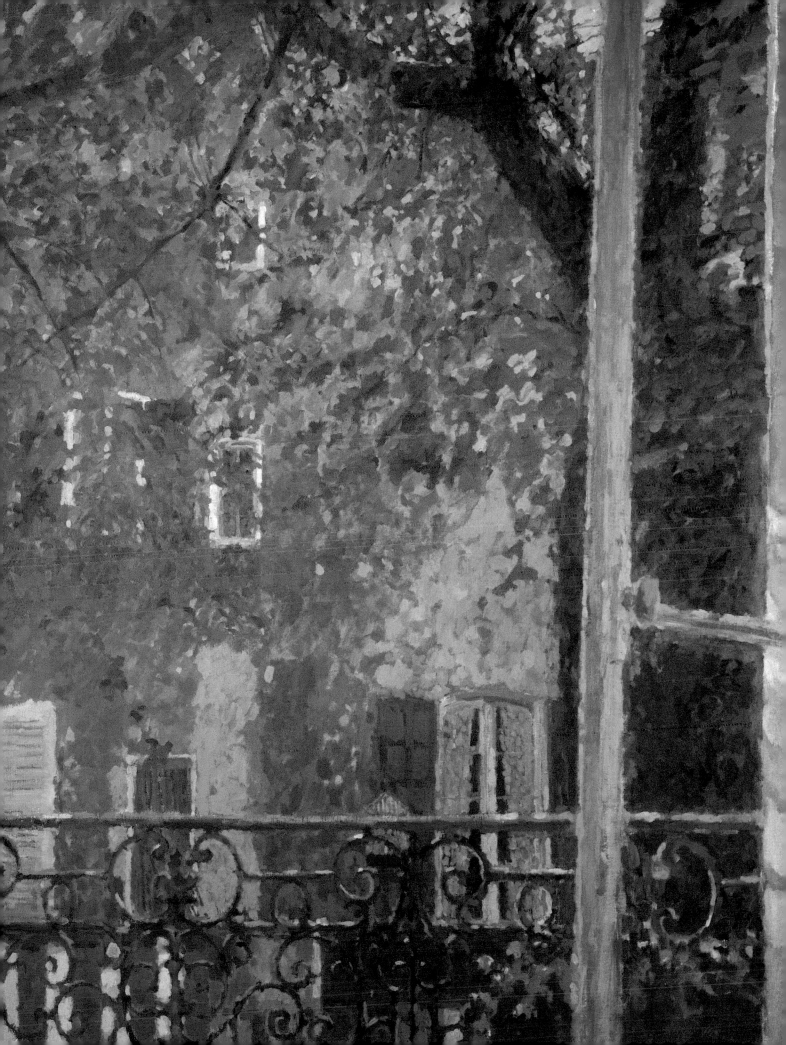

Landscapes

There is tremendous potential for landscapes as a subject, whether in the form of panoramic views or as more specific scenes, features and details, and this has made it a popular choice for artists since the 17th century. Moreover, with the influence of light and weather, each landscape has its own unique mood and sense of place, and the process of capturing these qualities in paint offers immense scope for personal expression.

For various reasons, including the sort of equipment that is required and the unreliable nature of light and weather, it is seldom possible to make a resolved, large-scale landscape painting on location. I occasionally paint small studies on the spot, working on prepared boards, but most of the time I make sketches and take photographs on site and use these as reference material for studio paintings. Sometimes, the biggest problem when starting the painting is deciding which part of a landscape to concentrate on. Always the answer to this, I think, is to focus on the area and the qualities that most impress you. The feature that usually attracts me to a certain landscape, or indeed any subject, is its uniqueness; the fact that there is something unusual about it.

*Below: **71. Automne du Midi***
Oil on canvas 61 x 86cm (24 x 34in)
Here, although the composition was straightforward enough, there was quite a challenge in achieving the right colour relationship between the sky and the autumnal trees.

Choosing Subjects

In landscapes, as in all my paintings, it is always the relationship of shapes and colours that interests me most. I try to find a composition that is different and challenging, rather than opting for the conventional landscape consisting of fairly equal bands of sky, background and foreground. For example, in *The Orchard, Normandy* (see below), I have taken a viewpoint that excludes the sky altogether, concentrating instead on the light and dark contrasts within the trees and the foreground flowers and grasses. Similarly, in *Meadow with Red Farmhouse* (see below), there is just a small amount of sky area, with the farmhouse itself almost in the corner of the painting rather than obvious and central, so creating a more challenging composition and leaving lots of scope for the foreground shadows, textures and colours.

Right: **72. The Orchard, Normandy**
Oil on canvas 70 x 77cm (27½ x 30¼in)
This was a hot, spring day and I wanted somehow to convey that effect as well as capture the varied greens contrasting with the blossom and flowers.

Right: **73: Meadow with Red Farmhouse**
Oil on canvas 66 x 86cm (26 x 34in)
By reflecting some of the red from the farmhouse into the foreground area and foliage, I have tried to create a greater unity between the various elements of the painting.

Left: **74. St Saturnin, Provence**
Oil on canvas 63.5 x 85cm (25 x 33¹/₂in)
*Always something to consider, with a
view such as this, is how to harmonize
the buildings with their setting. Usually
it is a matter of judging the right tonal
balance between the buildings and the
landscape.*

One of the main problems with landscapes as a subject for painting is that they can
be unrelentingly green. This is especially true of the British landscape. Green can
be a very difficult colour to control, as it can so easily become a harsh, acrid
colour that will dominate a painting, especially if you rely on paint straight from a
tube. I always mix greens, but even so, I prefer Mediterranean landscapes, which
tend to include less intense greens and more ochres and browns. Creating colour
harmonies and contrasts with these subdued greens, as shown for instance in *St
Saturnin, Provence* (see above), can be just as effective as working with a range of
more vivid greens. In other paintings, such as *The Olive Grove* (see page 75), I might
choose to use green with its complementary colour, red, and create a more
obvious pattern effect.

A Sense of Place

A landscape painting should try to go beyond being simply interesting and
descriptive. It should convey the special mood and atmosphere of the scene. In
fact, I would say that the emotional quality is more important than a concern
for accurate depiction. For me, the feature that most distinguishes one landscape
from another is not so much the content and composition as the particular quality
of light. The light influences the various shapes and colours in the landscape, and
it is by trying to capture that effect that we evoke a special feeling and sense of
place in our paintings.

Because light and colour are so crucial to my working method, I prefer to keep
more or less to the compositions that I find in nature rather than attempting to
alter the position of anything radically. I may sometimes adjust the placing of a tree
or other feature very slightly, or perhaps condense the space between things, but I
never make major changes. In my experience, if you remove something from the
view that you want to paint, or move it somewhere else, it can be very difficult to
fill the resulting space convincingly. This is particularly true when you are trying to
create a certain flow of light and shadow across the subject and capture the distinct
time of day and mood. It is always difficult to reinvent nature in a way that fits
perfectly into a picture.

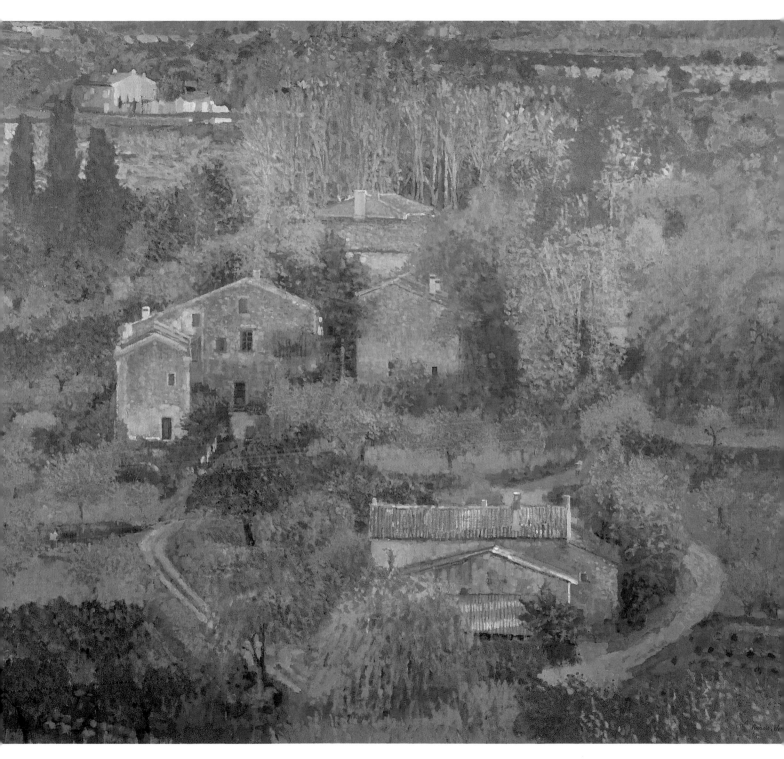

Above: **75. Landscape in Provence**
Oil on canvas 109 x 127cm (43 x 50in)
I liked the challenge of the high
viewpoint for this subject and the
general scope of the scene, with
lots of interesting details.

Left: **76. Jardin à l'Ombre**
(Stage 1)
Oil on canvas 69 x 78cm (27 x 31in)
My concern in the underpainting, which
is mostly in blues and greys, was to
create a good tonal balance for the
composition. It is easier to make
alterations at this stage, providing the
colours are kept subdued.

Left: **77. Jardin à l'Ombre**
(Stage 2)
Oil on canvas 69 x 78cm (27 x 31in)
Now I am beginning to develop the
feeling of a particular quality of light,
with the foreground shadows contrasting
against the sunlit background.

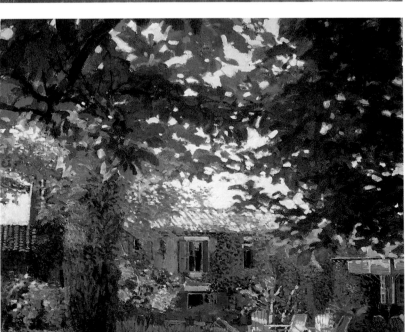

Left: **78. Jardin à l'Ombre**
(Stage 3)
Oil on canvas 69 x 78cm (27 x 31in)
Finally, I enhance the darks and
lights still further, to add to the
interest and impact.

Skies and Foregrounds

Skies and foregrounds are often considered as subordinate parts of a landscape painting, with all the action taking place in the middle ground. However, in my landscapes, while I always include a main focal point, and the composition is carefully devised to lead the eye through the picture plane, my aim is to create activity and interest throughout the painting.

So, when I do include a sky area, I want it to contribute in a positive way to the painting – perhaps in its colour harmonies and textures, for example. I don't think the sky should be merely an undifferentiated blue background. Similarly with the foreground, which can so easily be overlooked and in consequence left as a rather empty, dull space. Many of my paintings have quite an expanse of foreground – *The Olive Grove* (see below) is practically all foreground – and I enjoy the challenge of making an interesting foreground work in relation to the rest of the picture. A successful foreground is one that strikes the right balance between the handling of colour and detail, and directing the viewer's attention into the picture.

*Below: **79. The Olive Grove***
Oil on canvas 84 x 109cm (33 x 43in)
What interested me about this subject was the very obvious contrast between the stark trees and the lively, colourful background.

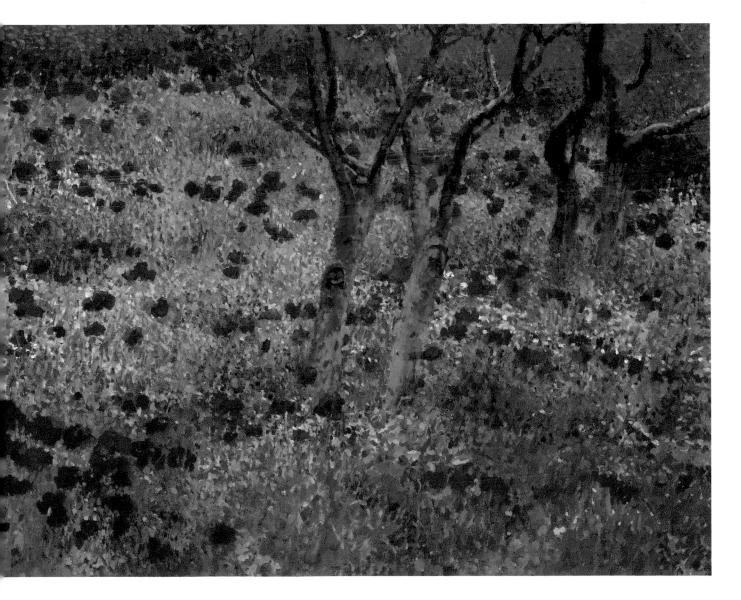

Still Life

As mentioned before, I never view a subject as belonging to a set category and therefore as having to be painted in a certain way. What attracts me to a subject is not the fact that it is a landscape, an interior, or whatever, but that it offers something challenging to paint. This is perhaps especially so with still life paintings.

I do occasionally set up a still life in my studio, but more often than not my still lifes are subjects that I have found quite by chance. *Fired Earth* (see opposite), which was inspired by a view of part of a potter's yard, is a good example. I particularly liked the sunlight filtering across the different pots, with their various shapes, sizes, colours and angles, and I immediately knew the subject would make an interesting painting.

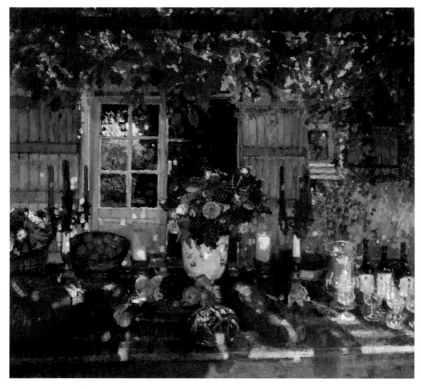

*Left: **80. Fin de l'Après-midi***
Oil on canvas 99 x 106.5cm (39 x 42in)
Mostly in shadow, here was a subject that reminded me of the dramatic chiaroscuro effects used by Caravaggio in his paintings.

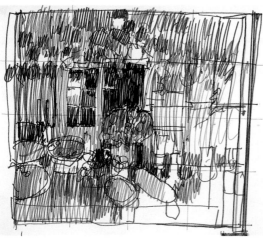

*Left: **81. Fin de l'Après-midi***
preliminary composition sketch, fibre pens

Right: **82. Fired Earth**
*Oil on canvas 91 x 108cm (35¾ x 42½in)
Again, it was the drama of light
and dark that appealed to me, and
perhaps the challenge of drawing
many different ellipses!*

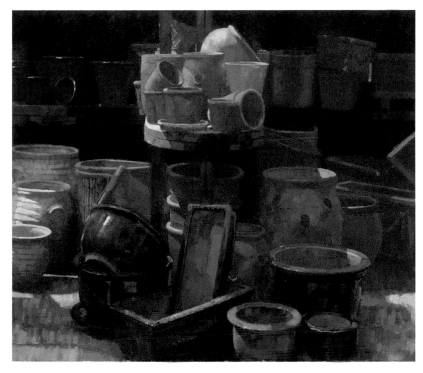

Below: **83. The Yellow Jug**
*Oil on canvas 91.5 x 122cm (36 x 48in)
The effect of evening light on a subject
can be very attractive. In this painting,
the rich diagonal light emphasizes the
positive shapes of the pots as well as
creating interesting shadows on the
walls in the background.*

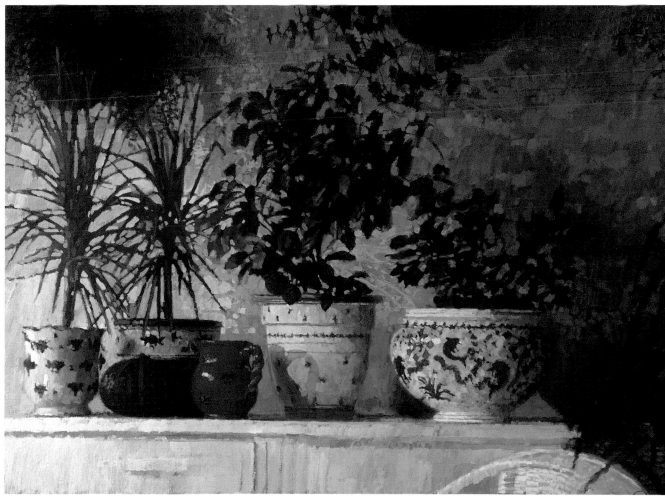

Scale and Design

Many of my 'found' still lifes are quite large compositions because, as well as the actual objects – which form the main still-life element – I like to include part of the surrounding area, to give context. The large scale adds to the challenge, interest and impact of the painting and, in contrast to a contrived arrangement in the studio, it encourages a sense of freedom and spontaneity. This is one reason why I particularly like Bonnard's still lifes. They are unpretentious, as though he has simply looked around his house and uncovered a corner that no-one had noticed before.

A still life group that is set up in the studio can look very artificial, but there are still ways to make it more exciting and less contrived. For example, instead of focusing solely on the objects, you could take a much wider viewpoint and include part of the room, or the window behind. Colour can also be exploited to add impact to still-life paintings. Try introducing a patterned cloth, for instance, or deliberately positioning one brightly coloured object against another.

Light and Form

Especially with still-life subjects, the use of light and shade adds a further, interesting dimension, and it also helps to link the different objects together and create a feeling of space and form. However, while I like to make the most of highlights and shadows to model the form of different objects, as with the pots in *Fired Earth* (see page 77), I generally subdue the overall sense of depth in my paintings. I am more interested in the play of colours and shapes, and this usually means that I enhance the background colours and so bring them forwards. But I try to use the colour harmonies and shadows in such a way that I maintain just enough sense of pictorial space, as for instance in *The Yellow Jug* (see page 77).

Light and shade can also contribute in a very effective way to the dynamics of the composition. In *The Dresser, Morning Light* (see below), for example, the shaft of bright light is crucial in focusing our attention on the objects and at the same time counteracting the strong horizontal lines across the picture. You may notice too that I often view the objects in profile, again because this helps with the colour and light-pattern effect. But where objects are tilted at an angle, and ellipses and other regular shapes are involved, I ensure that these are drawn accurately, because I know that any faults in such shapes will prove very obvious in the final painting.

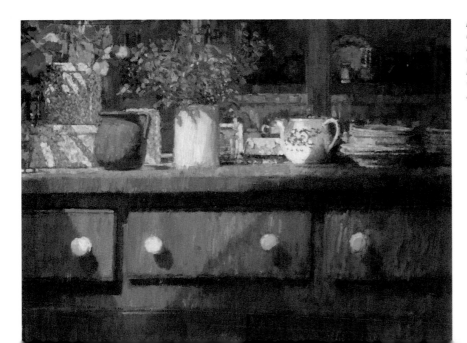

Left: ***84. The Dresser, Morning Light***
Oil on board 53 x 66cm (21 x 26in)
In contrast to Fired Earth (see page 77),
where the viewpoint was from above,
here the objects are at eye-level,
which avoids the problem of painting
accurate ellipses.

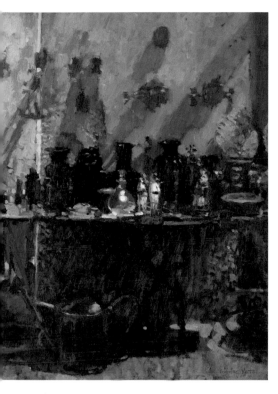

Interpretation

You may think it difficult to make a personal response to a still-life subject, and so create a painting that has feeling and originality. However, I believe you can paint a still life that is evocative and individual, and there are several ways of doing this. Lots of still-life paintings show a very conventional approach to the subject and, although they are skilfully painted, they are nevertheless rather dull and unimaginative. I think there is little point in choosing a subject that doesn't inspire you, or indeed painting it in a way that doesn't reflect your thoughts and feelings. Like any other form of painting, a still life must offer something original and exciting to the viewer. You can create these qualities within the arrangement or composition of the still life with a bold use of colour, by adopting an unusual viewpoint or form of lighting, or by using an expressive technique. A good way to help decide what will work best is to make a sequence of small sketches that you can compare and analyze.

*Above: **85. Blue Glass***
Oil on board 39 x 31.5cm (15½ x 12½in)
I particularly liked the strong blue of the vases in this interesting still life which I 'found' in a Parisian antique shop.

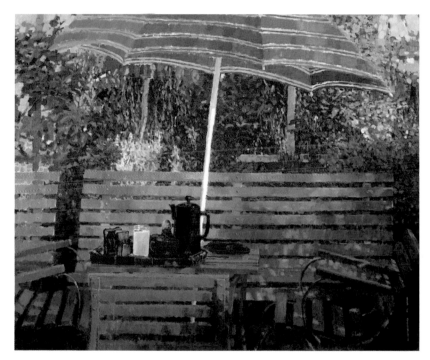

*Right: **86. The Pink Umbrella***
Oil on canvas 94 x 111.5cm (37 x 44in)
With the horizontal lines and simplified foliage, there is an almost abstract feel about this subject, yet with a contrasting touch of reality in the centre.

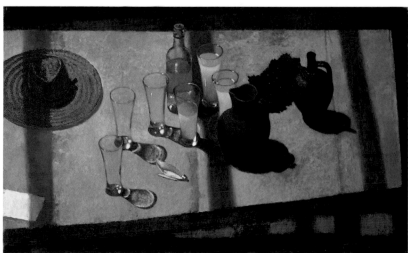

*Right: **87. The Stone Table***
Oil on board 58 x 91cm (23 x 36in)
Another interesting possibility for a still life subject is to take a viewpoint from directly above. Also here, I liked the way that the shadows created a structure for the composition.

Left: **88. Still Life with Sunflowers**
(Stage 1)
Oil on canvas 104 x 113cm (41 x 44½in)
My aim in this painting was to use the sunlight to direct the viewer's attention to the main still-life area. In the underpainting I have started to develop this idea, with directional patches of colour coming in from the right and also from the top left.

Left: **89. Still Life with Sunflowers**
(Stage 2)
Oil on canvas 104 x 113cm (41 x 44½in)
As the painting progresses I also begin to consider the contrasts between the fairly abstract background shapes and the foreground objects.

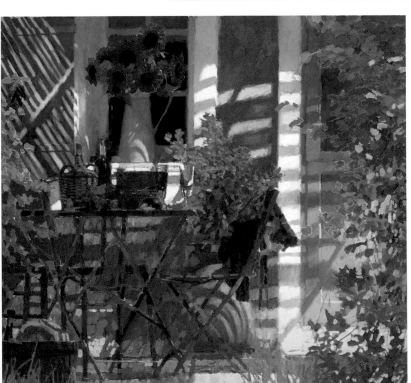

Left: **90. Still Life with Sunflowers**
(Stage 3)
Oil on canvas 104 x 113cm (41 x 44½in)
Finally, I concentrate on how the various colours balance and interrelate. The problem with so many different colours is that they can easily clash.

Flowers and Gardens

As with most of my paintings, the ideas for the flower and garden pictures are usually discovered quite by chance. I do not go out specifically looking for flower subjects, or visit gardens with the express intention of painting them. Rather, if I come across a good idea when I'm travelling around, I make a note or a sketch, or I take some photographs for future reference.

What attracts me to flowers, and why I think they make good subjects to paint, is the way they create a bright contrast with the surrounding landscape or other setting. They are always the focus of attention. Put a pot of bright flowers in a room and that's where your eye will go – because of the vibrant colour. I try to exploit that idea in my paintings, using contrasts and patterns of colour to make an interesting composition.

*Below: **91. L'Escalier du Jardin**
Oil on canvas 134 x 122cm (53¾ x 48in)
With a complex subject such as this, it is essential to work out a tonal rhythm that runs through the picture to give it meaning and coherence.*

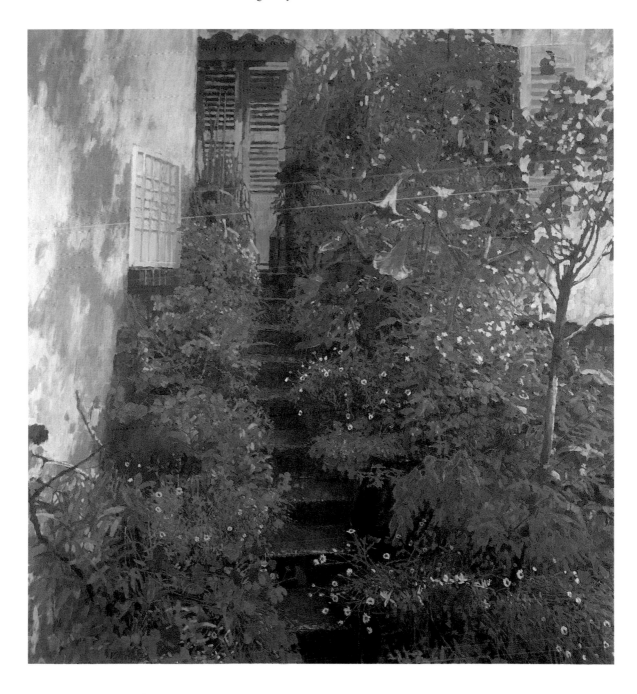

Exuberant Colour

One of the greatest challenges when painting flowers is in creating the correct
tonal and colour relationship between the flowers and the background. Almost any
colour arrangement can work – complementary colours such as red against green,
for example – but the difficulty is in achieving the right degree of contrast without
it looking too stark.

There are a number of factors that must be considered when assessing the colour
harmonies and relationships in a flower painting: how varied a colour palette to
use, for instance, or whether to enhance the background colour or perhaps subdue
the flower colour. However, the first step for me is always to observe closely what
actually happens in the subject. If the colour works in nature then it should work
in your painting, albeit with one or two thoughtful adjustments.

Red and green are the predominant colours in *The Poppies* (see above), and this is
always a difficult colour combination to use
successfully. Although red and green are both
naturally mid-toned colours, and are also
complementary colours, the relationship can
easily result in a rather brash, disjointed
effect. To help overcome this in *The Poppies* I
have slightly exaggerated the yellow and
white areas of the background and introduced
a few dashes of each of these colours into the
poppies themselves, so creating a link
between the two areas. This effect is further
enhanced by the fallen red petals on the table.

My liking for the play of light and shadow
across a subject can also be a factor that
influences the rich colour harmonies in a
flower painting. In *Sunflowers* (see right), most
of the foliage is in shadow, and this has
subdued what otherwise might have been
quite a vivid selection of greens. Also, I have
mixed some of the yellow flower colour with
the green for the surrounding leaves, and
again hinted at this colour in other parts of
the picture, thus adding to the colour
harmony of the painting.

Painting Foliage

At first glance the extent and variety of foliage seen in a garden subject can look far too difficult to contemplate painting. However, as with any subject, initially it is a matter of viewing what is there in terms of the general shapes, masses and colours, rather than being distracted by detail. When I paint a tree, I don't think of it as being, for example, a sycamore tree, which therefore must be portrayed with hundreds of sycamore-type leaves to make it look right. Instead I concentrate on the overall characteristics of the tree; the main shapes, textures and colours that form it.

*Right: **94. Daisies***
Oil on canvas 111.5 x 132cm (44 x 52in)
Here, the interest for me was the contrast between the red geraniums and the white daisies, and how I could make those colours work together successfully.

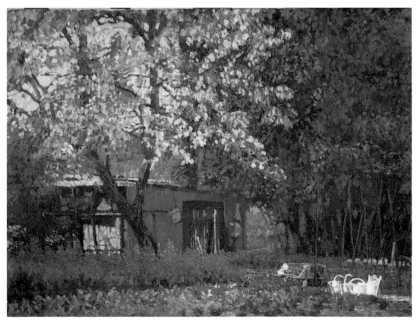

*Right: **95. Spring Garden***
Oil on canvas 64 x 82.5cm (25 1/4 x 32 1/2in)
The best approach for foliage, I think, is to concentrate on the general shapes and characteristics, rather than thinking about individual leaves and details.

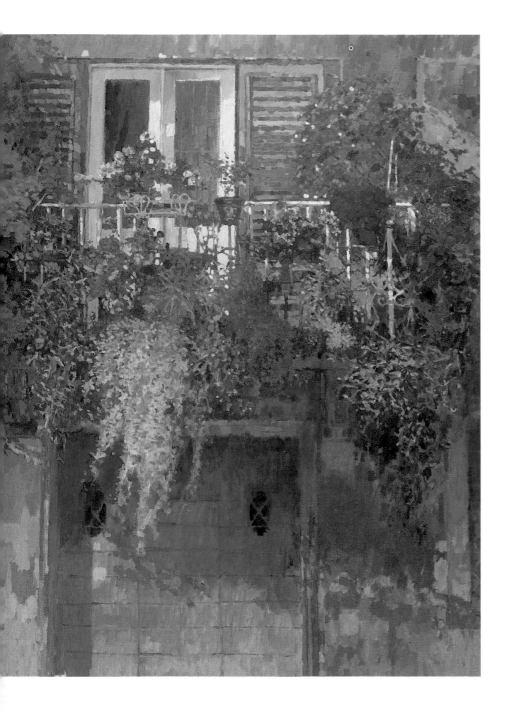

Left: ***96. Le Balcon en Surplomb***
Oil on canvas 114 x 86cm (45 x 34in)
There is always plenty of colour and
potential in this type of subject, which
is typical of Mediterranean countries.

When painting any type of foliage, if the important features and qualities are tackled convincingly, then you will convey the appearance and feeling of that foliage without the need for more specific detail. My advice is to start with the large shapes and then develop and define these just enough to make the foliage look right. Textures, colour and light are the main qualities to focus on.

Observation and simplification are key issues. As so often is the case in painting, depicting foliage is chiefly a matter of conveying an impression of what is there – relying on reality but concentrating on the essentials. Making the picture 'feel' right is inevitably more important than making it 'look' right. 'The art of deception' is how Degas described this approach.

Foliage, particularly in trees, often presents a broken rather than solid appearance, so that you can see the sky or other background colour showing through. You might suppose that the logical method of dealing with this would be to paint the background first and then paint the foliage over it. However, I never work in this manner. I regard every area as contributing in an equally positive way to the final impact of the painting and I like to develop the entire picture surface at the same pace. In my view it is unwise to commit yourself to a specific colour scheme too early in the painting process. Inevitably colours will have to be adjusted as the painting develops.

Also, because of the way I work and my interest in the pattern and relationship of colours, the underlying colour is always a very important consideration. Thus, to create the right colours and effects for the foliage, I may well need a specific colour underpainting in these areas, rather than simply working over the sky colour. Additionally, this approach keeps the colours pure and fresh, by avoiding unnecessary layering of one colour over another. In fact I often add the patches of sky at quite a late stage in the painting, when I can make a better assessment as to the tone and colour required.

Below: 97. Jardin Exotique
Oil on canvas 104 x 153.5cm (41 x 60½in)
The excitement of this subject was the drama between the foreground and the background, in terms of scale, colour and light.

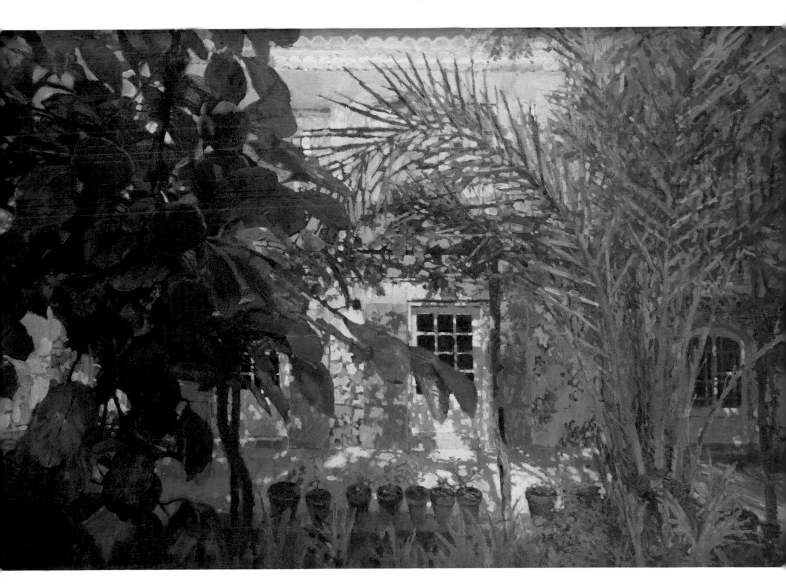

Interiors

Interiors offer lots of potential for exciting paintings, especially if, like me, you are interested principally in light and colour. As in all my work, I generally choose an interior subject that I can work from 'as found', for although I may simplify certain aspects and exploit the colour possibilities of the scene, I seldom make any significant alterations to the view that I have chosen. For me, composition is intrinsically linked with the selection process, so that in choosing a viewpoint I am also deciding on the composition.

Contre-jour

To make the most of the light effects, I like to choose a viewpoint from which I can either look across a room and out through a doorway or window towards a brighter area beyond, or vice versa. I find that this approach – called *contre-jour* (against the light) – produces very interesting compositional and lighting effects within the painting, as can be seen for instance in *The Library* (see opposite). But with any interior/exterior subject, the first thing to decide is which aspect to focus on – either the objects and colour within the room, or what is happening outside. In *Cabine de Plage* (see below), for example, I have placed a greater emphasis on the outside.

A quality that I always enjoy trying to capture is the contrast between bright daylight outside and warm reflected light in the room. In turn, these two types of light each evoke a certain mood, and this is another important, challenging aspect to tackle. Again, *Cabine de Plage* demonstrates this point: there is a sense of bright light and heat outside, but the inside looks cool and shady.

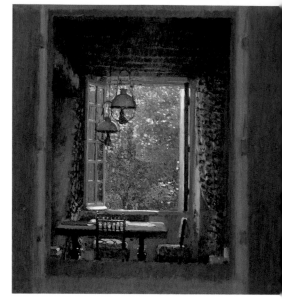

Above: **98. Summer in the Forest**
Oil on board 76 x 61cm (30 x 24in)
Contre-jour subjects make very interesting paintings. Here, the interior is darker and cooler, in contrast to the sunlit, hot atmosphere outside.

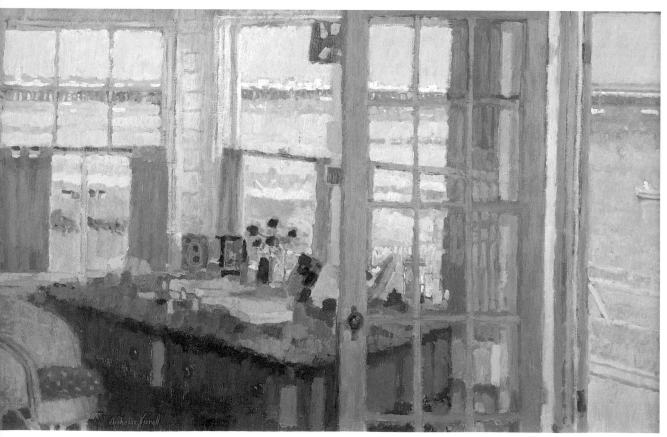

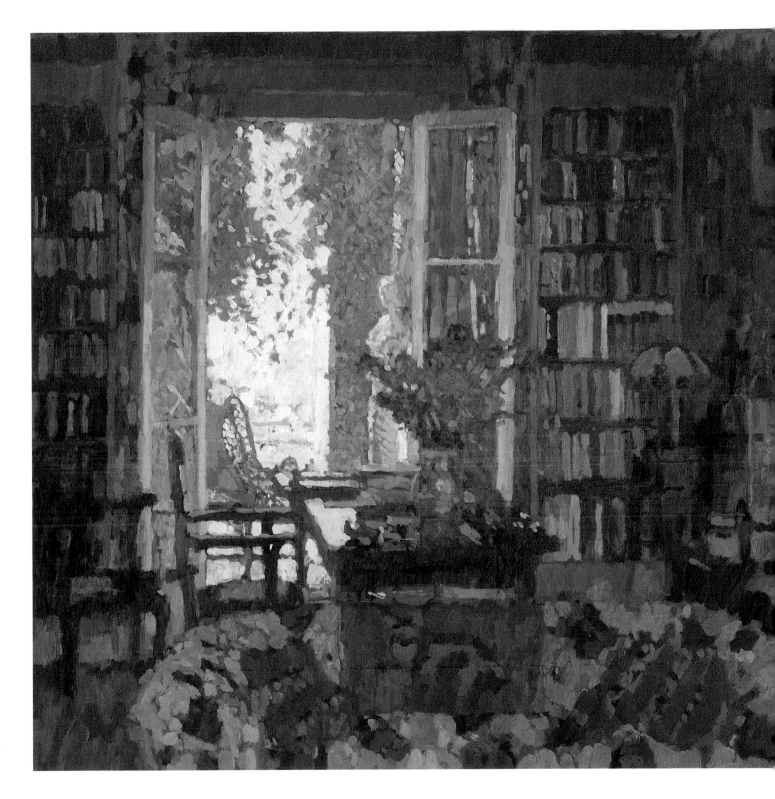

Left: **99. Cabine de Plage**
Oil on board 52 x 85cm (20½ x 33½in)
Again, this is a subject of contrasting
moods, between the shade of the
interior and the summer beach scene
outside, yet it has been achieved with a
very limited palette of colours.

Above: **100. The Library**
Oil on board 58 x 61cm (23 x 24in)
Full of patterns, this was a scene that I
greatly enjoyed painting.

Simplification

A subject such as that shown in *The Library* (see page 87) or *The Little Study* (see below) is, in reality, quite complex in its content and composition, and must therefore be simplified in some way. Although I don't alter things very much as far as the basic structure of the subject is concerned, I do tend to 'flatten' the general sense of space, by thinking in terms of blocks of colour rather than chiaroscuro (light and dark) modelling effects. Thus, I concentrate on the interaction of shapes and colours rather than aiming for a strong, three-dimensional feel.

As well, I try to interpret everything in terms of marks and areas of colour rather than getting involved in too much detail. In fact, if you isolate parts of *The Little Study*, for example, you will notice that the paint handling creates quite an abstract effect. But in the overall painting my aim is to make the various marks, strokes and patches of colour work together to convey the special mood of the interior and its sense of place. I try to use just enough detail to describe what is going on, while keeping the peripheral areas less detailed and defined, so that your eye is drawn through the room.

Below: **101. The Little Study**
Oil on board 45.5 x 55cm (18 x 21³⁄₄in)
I often work on a prepared medium-tone tinted board for interior subjects. This enables a very direct approach, starting with the main verticals and horizontals – the basic structure of the scene – and then developing the textures and colours.

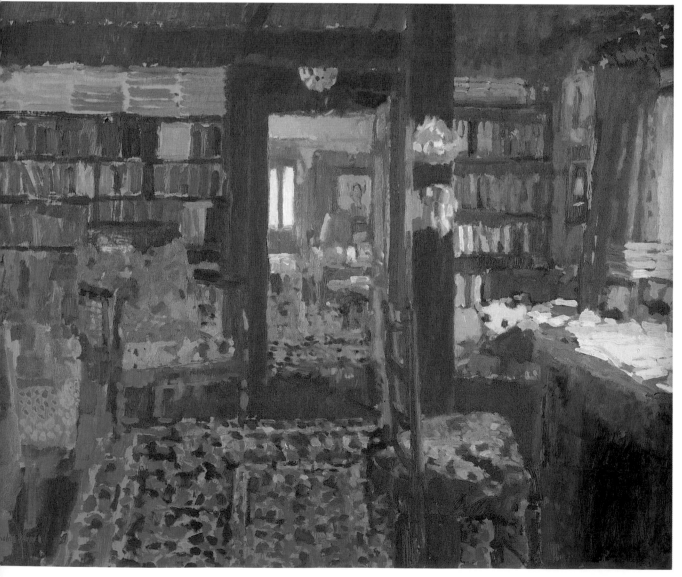

Above: **102. Soleil sur la Terrasse**
*Oil on board 51 x 45.5cm (20 x 18in)
I prefer working on a smaller scale for
interiors, and this is another reason why
I usually paint on board rather than
canvas. The smaller scale seems to suit
the intimacy of the subject matter.*

Right: **103. Anemones by the
Open Window**
*Oil on board 58 x 76cm (23 x 30in)
This could almost be regarded as a still-
life subject, but with a very interesting
light effect and just a hint of the rooftops
and buildings outside.*

Spatial Awareness

It is difficult to imagine an interior that doesn't include straight lines, objects placed at an angle to you and similar structural and design elements. Such lines and angles are obviously important and consequently it is often assumed that they must be drawn very accurately and with a knowledge and application of perspective. However, I would advise a more intuitive approach. It is never helpful, I think, to be too reliant on the use of perspective or too worried about getting the edges of doors and other objects absolutely straight.

Of course, window frames, doorways, chairs and other things must look right, but this doesn't necessarily mean that they have to be drawn with the help of a ruler rather than a brush. Perfectly straight lines tend to stand out, looking rigid and obvious and thus becoming a distraction. Similarly with perspective: while it is useful to think about how perspective might be relevant to a certain situation in order to get the lines and angles correct, it is not a good idea to apply the theory too vigorously. If you do, this too will look artificial and out of keeping with the rest of the picture.

In general I try to avoid viewpoints that involve depicting an exaggerated perspective. For an interior subject, one way to achieve this is to find a composition in which a table, sofa or another object fills up some of the foreground space, as in *The Library* (see page 87). Alternatively, choose a view that is more contained, perhaps towards one end of a room, as in *Soleil sur la Terrasse* (see left). And while I 'flatten' the sense of space as much as I dare, I try to compensate for this through the careful placing and tonal relationships of colours. For example, in *The Little Study* (see opposite), I have enhanced the composition by underplaying the perspective of the carpet, instead relying on the use of colour to create a sense of spatial recession.

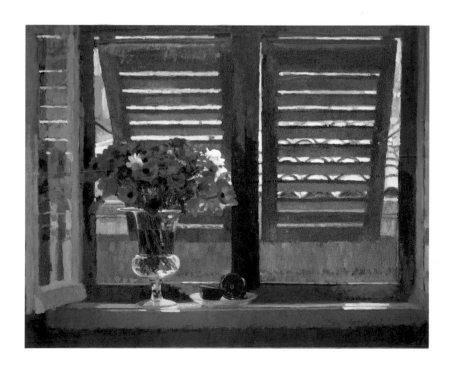

Façades

Of the various subjects that I enjoy painting, a façade offers me the greatest scope to develop the picture area primarily in terms of shapes, colours and textures. When painted from a close-up and face-on viewpoint a façade is essentially a flat, vertical surface, which means that there is an immense potential to exploit the geometry of the subject and its inherent abstract qualities.

I like to find façades that have a play of light across them, as this not only adds further interest to the subject but also creates opportunities to imply just enough sense of depth and dimension. Other ways to make the façade look convincing and suggest that it has form and depth include using reflections, as in *The China Shop, Provence* (see opposite), and hinting at buildings that appear in the distance, as in *Vieux Nice* (see below).

*Below: **104. Vieux Nice***
Oil on canvas 85.5 x 123cm
(33³/₄ x 48¹/₂in)
The subtlety in the different textures of façades offers plenty of scope for interesting subjects to paint.

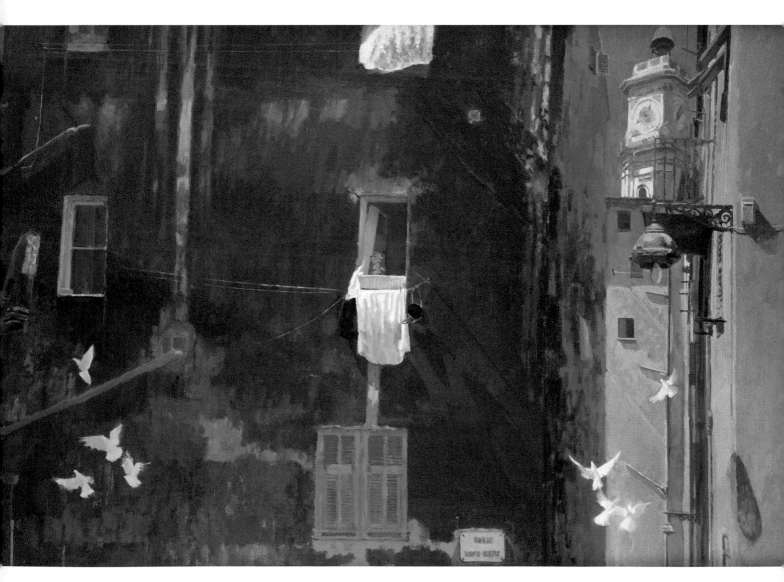

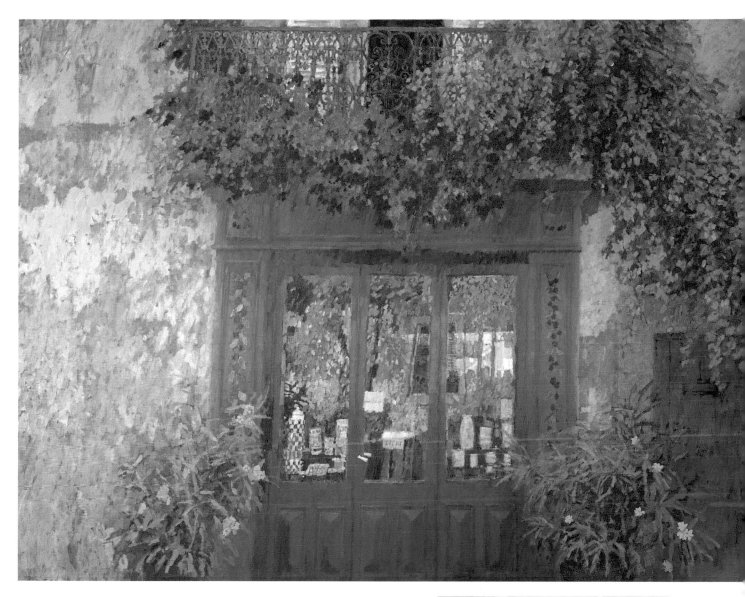

Above and detail right: **105. The China Shop, Provence**
Oil on canvas 122 x 152.5cm (48 x 60in)
In a subject that is essentially a flat façade, a convincing sense of space and depth can be achieved by making the most of reflections in the glass windows.

Light and Shade

The contrast between the light outside and the darkness within the building is another quality that will give the façade a feeling of structure and form. In *Epicerie* (see below) for example, the dark doorway, with the light just catching some of the items inside, suggests some perspective and depth, and also creates a focal point. The way the light travels across the subject is also something that can be used to advantage. I note the direction from which the light is coming, which is normally the most vibrant part of the picture, and I make as much use as I can of the variations of light and shadow to break up the picture surface. In *Le Droguerie, Provence* (see below), the façade is enlivened by a variety of shadows, making the architecture less stark and adding a strong sense of mystery and atmosphere.

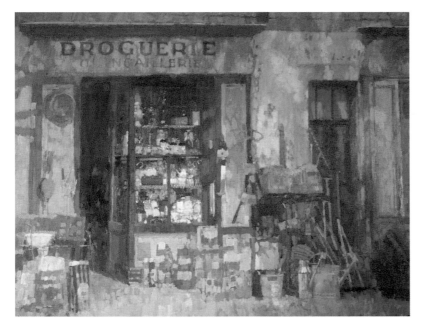

Left: **106. La Droguerie, Provence**
Oil on canvas 96.5 x 124cm (38 x 49in)
With a complex subject, I think the best approach is to work from big shapes to smaller ones, gradually refining everything until you have the amount of detail you want.

Left: **107. Epicerie**
Oil on board 45 x 56.5cm (17³/₄ x 22¹/₄in)
A shop front such as this is a real inspiration to use colour!

Above: **108. Le Mur Jaune**
Oil on board 56 x 58.5cm (22 x 23in)
This in fact is a very simple subject,
but the combination of shapes, shadows
and colours creates a surprising degree
of interest.

It can be quite difficult to make a shadow look as if it is falling across the surface of a wall or other object and that it is in fact a cast shadow rather than just another dark patch of colour. Success relies on creating exactly the right balance of tones between the lit surface and the shadow, for if the shadow is too bold in colour or too defined, then it will seem to jump forward and be detached from the background. An important consideration in making the shadow look convincing is the colour of its edge, where shadow and background connect. In my experience this colour is usually slightly richer than the surrounding colours, as can be seen in *Le Mur Jaune* (see above), where I have used a slightly more orange-yellow colour for the edges of the shadows.

The colour of a shadow is invariably a challenging thing to judge. However, for a shadow, as for any other part of a painting, I think it is always best to be positive about the colour. Rather than start with, say, a grey, nondescript tone, have a close look at the shadow and how it relates to its surroundings, and then commit yourself to an obvious colour or combination of colours. It probably won't be the right colour straight away, but you can always make adjustments later, as the painting develops.

Surface Textures

Façades can involve an incredible range of surface textures, from flaking, painted plaster to panelled wood and ordinary brick. Moreover, changes in the quality of light can further influence the appearance of such textures, perhaps enhancing or subduing them, and so adding to the variations that are possible. It follows that the painting process used to interpret each texture must vary according to the effect required. Broken colour, glazing, scumbling, impasto, stippling and similar brushwork techniques are the most suitable for creating different textures. See Painting Techniques on page 28.

Two paintings that demonstrate quite different texture effects are *Vieux Nice* and *The Shaded Courtyard, Provence*. In the first painting the wall surfaces are quite smooth and I have relied mainly on glazing techniques, while in the second example you can see that much of the paint has been applied as fairly thick dabs and dashes of colour to create an obvious textural effect. Where possible I keep to one main technique throughout the painting, since this gives a coherence. But, as in *The China Shop, Provence*, I like to vary the application of the technique (in this case the size of the dabs of colour) to suit the different surfaces within the subject.

Below: **109. The Shaded Courtyard, Provence**
Oil on board 40.5 x 61cm (16 x 24in)
Interestingly, most of the light in this scene is reflected from the ground area, giving it a very distinctive kind of mood.

Venice

I first went to Venice about thirty years ago and I have made occasional return visits to this unique city ever since. Over the years I have amassed a huge collection of photographs and sketches, and these continue to prove extremely useful whenever I am inspired to paint a Venetian subject. Venice is full of ideas for artists, particularly those who like subjects that evoke mood and atmosphere, so it is not surprising that so many painters are captivated by the wonderful architecture, light and colour that they find there.

Above and detail right: **110. The Little Antique Shop, Venice**
Oil on canvas 97 x 107cm (38 x 42in)
The character of Venice can be captured in many different ways, not only by painting the obvious views.

Above: **111. Summer Heat, Venice**
Oil on canvas 103 x 122cm (40½ x 48in)
I liked the arrangement of shapes and
different textures here. Again, I have tried
to convey the feeling of Venice without
choosing one of the main tourist sights.

In fact Venice has been a favourite subject with artists since the time of Canaletto in the 18th century, which maybe is one reason why it is a difficult subject to paint. There is such a wealth of fine paintings that precedes us, and every danger that our work might be compared to these! However, with Venice, as with all subjects, the important thing to remember when painting is to be true to yourself – express what you see in your own style and in a way that reveals your personal thoughts and ideas about the city.

Viewpoints

Especially in Venice, because it is both an architectural subject and somewhere that is instantly recognizable, it is crucial to find exactly the viewpoint you want. In my experience architectural subjects can so easily look wrong and unconvincing if you try to alter their basic appearance, so accurate reference is essential. Of course this doesn't mean that you have to record every detail or aim for a photographic level of accuracy, rather that the general shape, the angles and the position of the main features of the buildings must be correct. Unlike in a landscape view, where moving a tree slightly or compressing the space between two objects might well improve the composition, with buildings I find that it is always best to accept what is there. Somehow architecture never looks quite right if you distort or simplify it too much.

Occasionally there are practical reasons that make it difficult to work from the ideal spot. There could be a lot of people or passing traffic, for example, that continually block your view. In such cases my advice is to get as much information as you can from your preferred viewpoint, but support this with additional reference material from slightly different viewpoints on either side. This particularly applies when making sketches or taking photographs that you intend using later as the main source of reference for a painting in the studio. Always collect more information than you think you need. It can be very frustrating if you get back home and realize you need to see a certain part of the view you haven't recorded, and now have no means of checking.

With architectural subjects, viewpoint and composition amount to essentially the same thing. Therefore the best view will be the one that not only gives you the scope to express what you feel is important about the subject, but also creates an interesting composition. In Venice, I try to find views that are a bit different from the well-known places such as St Mark's Square and the Rialto Bridge. I like views that somehow evoke the spirit and architecture of Venice yet allow me an interpretation that is slightly more abstract in concept, with an emphasis on flat pattern and colour.

*Right: **112. Reflections, Venice***
Oil on canvas 96 x 79cm (38 x 31in)
Venice is full of wonderful reflections,
offering immense potential for creating an
exciting painting surface.

Colour and Atmosphere

Venice has a magical atmosphere, and it is this special effect that artists try to capture in their paintings. However, if the choice of colours is not quite right or the painting becomes too neat and tidy, then the ethereal quality and the feeling of light and mood is soon lost. This is something I notice occasionally in paintings that I see in different exhibitions. It can be particularly apparent in the way that the water, reflections, and the relationship of buildings to water are painted. The main thing to be wary of is not to overwork the water or make it too dark – and therefore menacing in appearance.

I usually soften the edges where buildings meet the water. As in *Venice Backwater* (see opposite), this helps to create the feeling of the buildings emerging from beneath the water. Also, I like to use colour in quite a positive way to interpret the light and mood at a particular time of day. The most magical light effects are in the early morning and the evening, but it can be a good idea to start painting in the middle of the day and gradually work up to the sort of atmospheric effects that develop later. See *The Grand Canal, Venice* below.

Above: **113. The Grand Canal, Venice**
Oil on board 33 x 53.5cm (13 x 21in)
I think capturing mood is more important than precise architectural detail,
although the main features of well-known buildings must be instantly recognizable.

Water

There are many different visual characteristics of water – its surface quality and depth, the fact that it is essentially transparent and includes reflections, its sense of movement and transience, and so on. This makes it an extremely interesting subject to express in paint, if a fairly difficult one!

Of course, many of the characteristics of a particular stretch of water are determined by the things around it. Consequently, the first step to interpreting the nature and mood of water lies in observation and trying to understand what is happening in terms of its colour, reflections and the influence of light, and how these aspects relate to the overall context. Next, particularly with moving water, it is a matter of generalizing or simplifying, so that you are in fact creating an impression of what is there, rather than aiming for detailed realism. But naturally your impression will place an emphasis on the qualities that interest you most.

*Below: **114. Venice Backwater***
Oil on board 48 x 53.5cm (19 x 21in)
The light effects in Venice are often dramatic. Here, I have used a sequence of blue glazes to create the right mood, adding the highlights in thicker paint last of all.

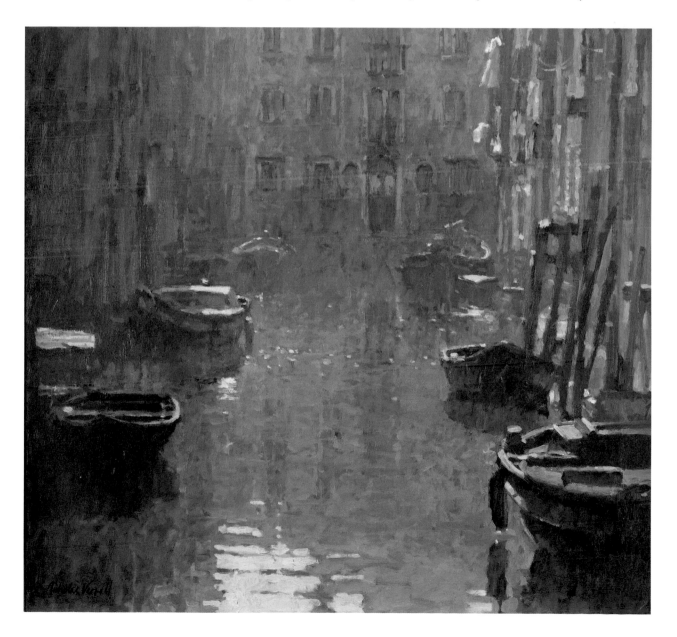

Colour in Water

Something that particularly fascinates me about water, as it did Monet, is the fact that it is both flat and three-dimensional; we see the surface but we must also imply a depth. Also like Monet, I love the challenge of conveying those dimensional qualities and the other characteristics of water in terms of colour. Moreover, I will usually apply the colour in quite a bold way, so that both the technique and the colour relate to the rest of the painting, as in *Lilies, Early Summer* (see opposite). Here you can see that the overall effect is quite abstract, with an emphasis on painterly qualities. But there is just enough indication of depth – by including the foreground irises, the horizontal stretch of water lilies, and the slightly darker tone beneath the rhododendrons and foliage at the top – to convey a representational meaning.

I faced a more difficult challenge in *Pool of Goldfish* (see opposite), in which the whole painting is the surface of the water. Although there is reflected colour and light, there is no direct reference to the source of these qualities and so the difficulty was in making the surface of the water look as if it were receding (flat and horizontal) rather than going vertically up in the air. There was also an additional problem with the goldfish, which had to look as though they were beneath the surface of the water. Essentially, both problems were resolved through the careful relationships of colours and the tonal strength of those colours. For example, the particular orange used for the goldfish was such that it held back rather than jumped forward. The pattern of light on the water also helps to carry the eye back, as if looking across the surface.

Above: ***115. Normandy, Early Morning***
Oil on board 58.5 x 66cm (23 x 26in)
Observation is the first important step to painting water successfully. Here, in the still water and the weak, morning light, the reflections were quite subtle.

Above: **116. Lilies, Early Summer**
*Oil on canvas 122 x 122cm (48 x 48in)
By thinking very carefully about the
colour relationships and the direction of
the brushstrokes, I have tried to convey
the impression of the lilies floating on
the surface of the water, as well as the
depth of the water beneath them.*

Right: **117. Pool of Goldfish**
*Oil on canvas 122 x 142cm (48 x 56in)
What appealed to me here was the
potential to make an almost flat
abstract picture that relied on
textures and colours.*

Another important factor, of course, is the way in which the paint is applied. In general I work with the 'feel' and texture of the paint, and I paint what I discover in the subject visually rather than what I know to be there. When painting water, the direction of the brushstrokes plays a key part. The more horizontal strokes you use, the more the surface of the water appears flat, whereas vertical strokes add a feeling of depth. Again, as with tonal relationships, success depends on creating the right balance of harmony and contrast.

I do not consider that some techniques are necessarily better for painting water than others, although generally I use positive marks of colour rather than glazes. Obviously you should choose those techniques that allow you the scope to convey the effects you want to achieve, which might mean that glazing, scumbling and blending are all suitable.

Reflections

As discussed, the visual appearance of water from above is essentially made up of reflections. Therefore, to capture the idea of water successfully the reflections must be considered an integral element in the development of the painting rather than areas that are superimposed later. In fact, as in *The Lock-Keeper's Cottage, Dordogne* (see below), the reflections often contribute in a vital and exciting way to the composition and impact of the painting.

Below and detail above: **118. The Lock-Keeper's Cottage, Dordogne**
Oil on board 40.5 x 51cm (16 x 20in)
On this bright, clear day the reflections were very positive, providing a challenging idea for a painting.

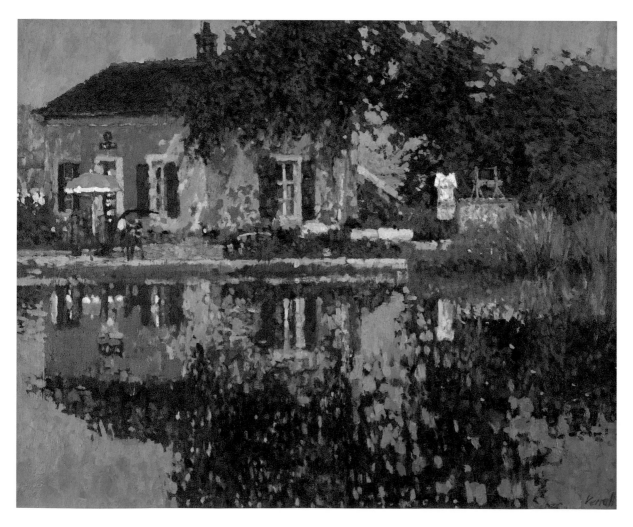

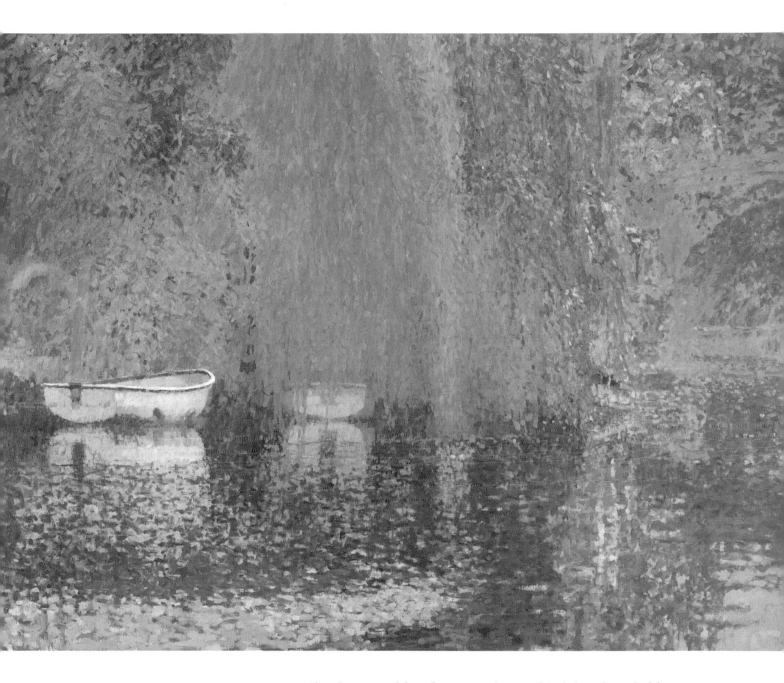

Above: **119. Summer Haze**
Oil on canvas 122 x 132cm (48 x 52in)
To create the feeling of a hot, humid
afternoon, I have painted the shadows as
positive colours rather than tones, and
also enhanced the effect of dappled light
in the trees and the water.

Also, the nature of the reflections is indicative of the light and mood of the particular day, and this is another factor that adds to their importance. Consequently, the way that the reflections are handled in terms of technique and paint quality will influence the overall perception of a certain atmosphere and time of day. In *The Lock-Keeper's Cottage*, for example, the reflections are crisp and clear, suggesting a bright, hot summer's day, while in *Summer Haze* (see above) the effects are more subtle, conveying the idea of the slightly misty atmosphere of early morning. Notice in both examples how important it is to relate the reflections and highlights in the water accurately to the actual objects.

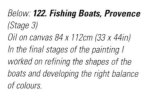

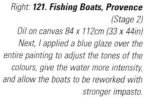

Left: **120. Fishing Boats, Provence**
(Stage 1)
Oil on canvas 84 x 112cm (33 x 44in)
I liked the viewpoint and the powerful
blue of the water in this subject and I
used strong colours from the very
beginning.

Right: **121. Fishing Boats, Provence**
(Stage 2)
Oil on canvas 84 x 112cm (33 x 44in)
Next, I applied a blue glaze over the
entire painting to adjust the tones of the
colours, give the water more intensity,
and allow the boats to be reworked with
stronger impasto.

Below: **122. Fishing Boats, Provence**
(Stage 3)
Oil on canvas 84 x 112cm (33 x 44in)
In the final stages of the painting I
worked on refining the shapes of the
boats and developing the right balance
of colours.

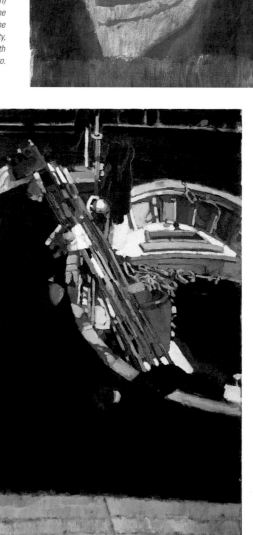

Figures

Comparatively few of my paintings include human figures. However, I do occasionally paint portraits and figure compositions, and there are many paintings, such as *The Pink Umbrella* (see page 79), in which I imply the past or impending presence of people. Alternatively, in some pictures I like to think that it is the person viewing the painting who is invited to sip the wine and sit in the empty chair that I have included.

I don't consciously avoid figures as a subject — in fact I regularly make life drawings and sketch figures. But I am usually more interested in other qualities and possibilities within the picture, such as the influence of light and the interaction of colours. For me, the inclusion of figures would detract from those qualities, because figures always attract attention to themselves in a painting. So, when figures are included, I try to ensure that they are not too dominant; that they create the right balance with other elements in the painting.

Below: **123. Le Figaro**
Oil on canvas 68.5 x 76cm (27 x 30in)
The position of figures is always crucial in a painting. Here, I have tried to place the figure so that it relates to the surroundings, but isn't too obvious.

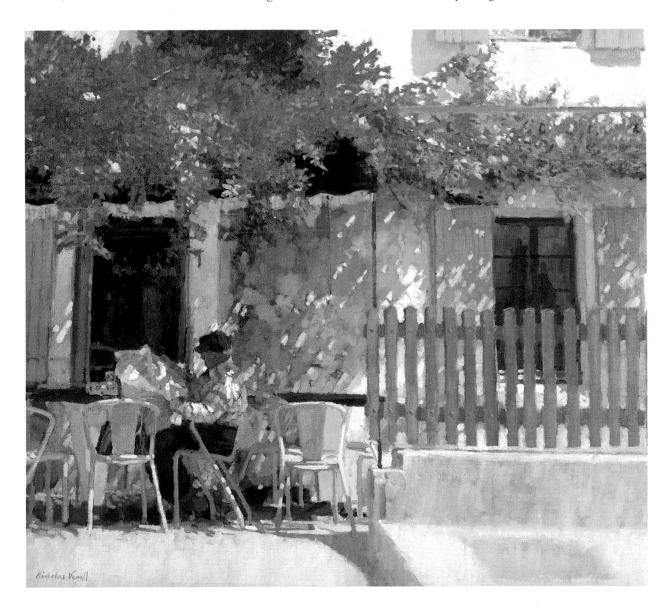

Observing Figures

If a figure is badly drawn, or the scale, proportions or some other aspect is wrong, this will be immediately obvious to anyone viewing the painting. Everyone knows what a human being looks like. Confidence in drawing and placing people in your paintings will come from a combination of access to good reference material (studies and photographs) plus the skills you have developed from observing and sketching figures. Whenever you have the opportunity, perhaps in a café, on a train or at home, make some little sketches of people – different poses, activities and so on. This is how you acquire an understanding of proportions and the way people move. Going to life classes is also very helpful.

When painting, after you have sketched in the shape of a figure, take some time to consider it objectively. Does it look right? Does it fit into the context properly? A useful check is to look at the figure in a mirror. I do this periodically with all my paintings. Somehow the mirror image seems to exaggerate any faults, perhaps because it simply presents the image to us in an unexpected way. Also, it is a good idea to put the painting aside for a while and come back to it the next day, when you can view it with a fresh eye. Usually, if a figure isn't quite convincing, it is a matter of tinkering with the proportions or slightly exaggerating the pose.

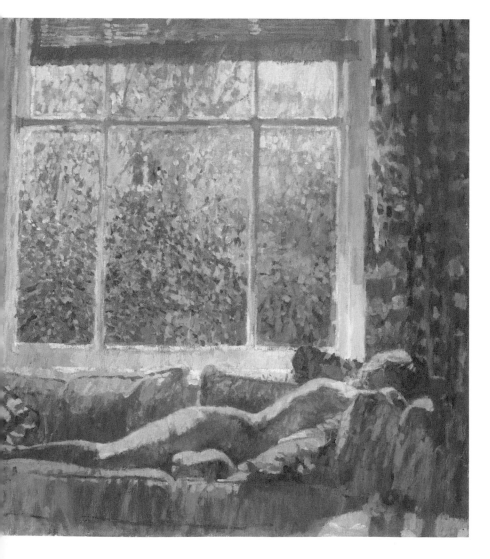

*Left: **124. Nude by a Window***
Oil on canvas 91.5 x 86.5cm (36 x 34in)
Again here, my aim was to avoid a composition in which the figure looked obviously posed. Like Bonnard, I think there should be a harmony between the figure and the setting, so that the figure is only marginally more important than the objects around it.

Portraits and Studies

With portraits there must be an even greater emphasis on observation and accuracy to create the likeness and character of the sitter. The two portraits I have included in this section, *Penny Blowing Bubbles* (see page 108) and *Petit Garçon sur la Terrasse* (see below), were commissions, and in both cases I began with some preliminary drawings. This is always the best way to get to know the sitter and observe their particular features and characteristics. I also took some photographs for additional reference.

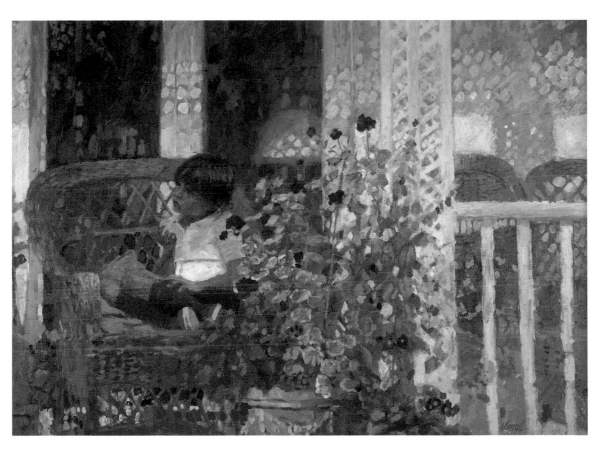

Above: **125. Petit Garçon sur la Terrasse**
Oil on canvas 76 x 109cm (30 x 43in) This was a commissioned portrait, but rather than ask the boy to sit in a chair, I waited for him to adopt his own 'pose'.

Right: **126. Petit Garçon sur la Terrasse**
Preliminary study, pastel.

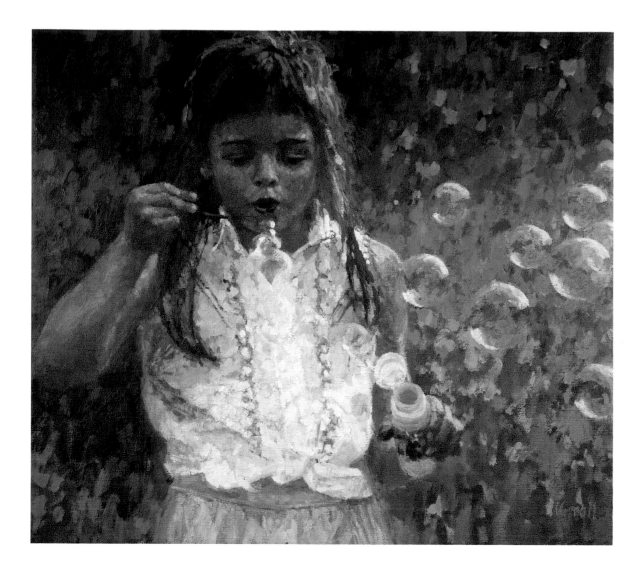

*Above: **127. Penny Blowing Bubbles***
Oil on canvas 71 x 86.5cm (28 x 34in)
Before deciding on the best way to make
a painting of a young child, to help you
find a composition that looks natural and
in character it is a good idea to have
plenty of sketches and photographs.

In my experience, the pose of the figure and the context in which it is placed are significant factors in creating a successful portrait painting. This is particularly so in the case of children. I wanted the two portraits (shown above and on page 107) to look natural, and I found I could achieve this by watching the children at play and catching a pose that was not only interesting but also seemed to say something about the individual child. In much the same way as a still life that has been arranged in the studio, a figure that is too carefully posed is in danger of looking contrived and lifeless. Also like a still life, the lighting and the subject's relationship to the background can make all the difference between a painting that is sound but dull and one that has energy and impact.

Figures in a Context

Often artists include figures as a compositional device to create a centre of interest, provide a sense of scale or add a narrative element to the painting. This can work very well, providing the figures look natural and comfortable within the scene, as though they were meant to be there. Generally, figure compositions that are painted from life, or that are based on reference material gathered from observation, are far more successful than those in which figures have been added from some other context.

In Bonnard's paintings the figures always work perfectly. They are never intrusive, in fact they are often such a clever part of the design that you only notice them after you have seen the rest of the picture. This is the sort of effect I aim for. In *Garçons, Aix-en-Provence* (see below), for example, the figures, with their dark waistcoats, blend well with the surroundings, and I have used a similar technique in *En Mettant la Table* (see below).

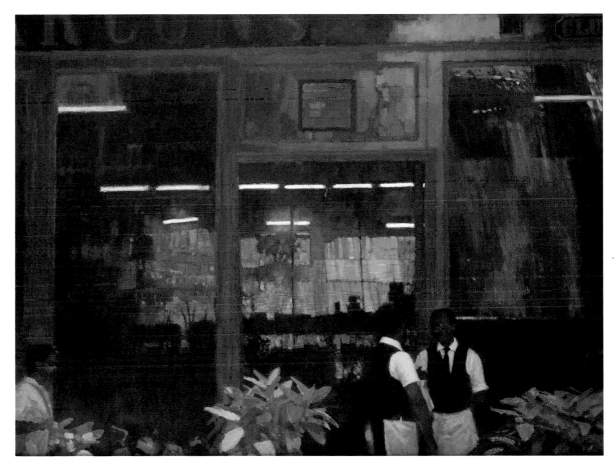

Above: **128. Garçons, Aix-en-Provence**
Oil on canvas 91.5 x 122cm (36 x 48in)
I liked the way that the figure seemed to fit perfectly into a scene that is essentially a series of abstract shapes.

Right: **129. En Mettant la Table**
Oil on board 57 x 56cm (22½ x 22in)
In this subject, it is the dappled light effect that links the figure into the rest of the scene.

The Working Process

Because of the scale of my paintings and the way that I like to compose and develop them, I normally work in the studio. Nevertheless, first-hand observation and the direct experience of different subjects is always important to me, and so the basic ideas in all my paintings evolve from reference material that I have gathered on location. This material is usually a combination of sketches and photographs, with the sketches providing a record of the specific qualities that excited me about the subject and the photographs offering a reminder of the scene, alternative viewpoints and other information about the location in general.

Obviously, finding your own style of painting takes time. But skills and confidence will gradually develop as you gain more experience with oil paint, just as your work will improve with practice, perseverance and a willingness to experiment and discover exactly what the medium will and will not do. There is no single method of painting that ensures success. Nor should there be, for the principal aim of painting is to express ideas in an individual way. However, oil paint is a wonderfully adaptable medium, and providing you respect its inherent qualities and characteristics you should be able to achieve precisely the sort of response and effects you want.

No two pictures are ever painted in exactly the same way. But there are quite a few design, practical and aesthetic considerations that apply to most paintings, and in this final section of the book I will be discussing these aspects in detail in relation to my own working process. I hope there are many useful points here that you can apply to your particular way of painting, and that my working process in general will help inspire you always to be looking forward to the next painting challenge. This sense of enthusiasm and expectancy is what will keep your work fresh, interesting and improving. In each new painting it is a matter of aiming somewhere between what you know you can do and what you would like to be able to do – to push ahead yet somehow keep just within your range.

Right: ***130. Le Relais à Mougins***
Oil on canvas 101.5 x 91.5cm (40 x 36in)

On Location

The majority of my subjects come from places that I have visited in continental Europe, particularly in Provence, northern Spain and Italy. In fact I used to spend several weeks each year travelling in search of new subjects, but now these trips are less frequent, as I have such a reserve of studies and ideas still waiting to be explored. For each trip I start with some research by looking at travel books and magazines to find interesting villages and other locations, but I never set out with specific subjects in mind. I enjoy the stimulus of unfamiliar places and the challenge of new ideas and fresh visual experiences.

Above: **131. Sketchbook studies**,
fibre pen

Above: **132. Sketchbook studies**,
fibre pen

Right: **133. Location photograph**

Below: **134. The Blue Boat**
Oil on canvas 119 x 122cm (47 x 48in)
The main reference for this painting was
the photograph shown on the right. With
photographs it is best not to copy what
you see, but to use the image as an aide
memoire to remind you of the mood and
other qualities of the subject.

Recording Information

My first priority when I arrive at a new location is to assess its potential in terms of subject matter and get acquainted with its particular atmosphere and sense of place. Initially I like to explore the area on foot, taking only my camera with me to record any subjects that look promising. Then, during the following days I return to the most interesting of these subjects to make some sketches, or perhaps to try a small painting.

How do I judge which subjects will work best? Well, I suppose I now rely mainly on my experience. I compare the qualities of a particular subject and estimate its potential against any similar ideas that I have painted before. I generally avoid the obvious piazzas and well-known views in a town or village. I try to find a personal and unique viewpoint, yet one that still conveys the character of the location.

For anyone who hasn't worked on location before my advice is to start with subjects that aren't too complicated. The advantage of making initial sketches is that they will show where the difficulties lie in the subject, and so help you decide whether you want to tackle it on a larger scale as a painting. But whatever the subject, it should be one you find exciting and fun to do.

There are two main features of the subject that I like to note in the sketches – the relative colour values and the composition layout. The colour is particularly important because it evokes a certain mood, quality of light or time of day, and usually these are the effects that I want to convey in the eventual studio painting. So I may try two or three quick sketches at the same spot, concentrating on colour and composition rather than troubling too much about the quality of the drawing or the details. The photographs will help with any information that I omit from the sketches, but I am always aware that photographs tend to be inaccurate when it comes to colour values, and can be misleading in representing the sense of space and scale. See illustrations 133 and 134 on page 113.

Sketching Techniques

I find that pastels or coloured fibre-tip pens are the best media for making quick, small-scale sketches to remind me of the colour relationships in the subject. I also occasionally use graphite pencils or black fibre-tip pens for linear and tonal sketches, perhaps making three or four of these on a page, working in an A3 sketchbook (297 x 420mm / 11^1/$_2$ x 16^1/$_2$in). Not all of the sketches will be successful or useful, but this does not matter. The real value of a sketchbook, I think, is as a place to try things out, jot down information, examine different viewpoints and possibilities for each subject, and so on. I use a sketchbook almost like a private diary – it is a working aid, not something precious in which all the drawings are carefully planned and wonderfully finished.

As well, I sometimes make small oil paintings on site, working on hardboard or millboard, as in *Les Volets Bleus* (see opposite). Often I use unprepared board, which absorbs the oil in the paint much more quickly. This means that I can work faster and, especially if I use thinned paint, try out whatever colours I need without having to wait long for certain areas to dry. When I have finished painting I press a drawing pin into each corner of the front of the board to make sure the painted surface does not touch the other wet boards when it is stacked in the box that I use for transporting paintings back to the studio. On location I work with a small palette, using fewer colours than I usually would in the studio, and much thinner washes of paint.

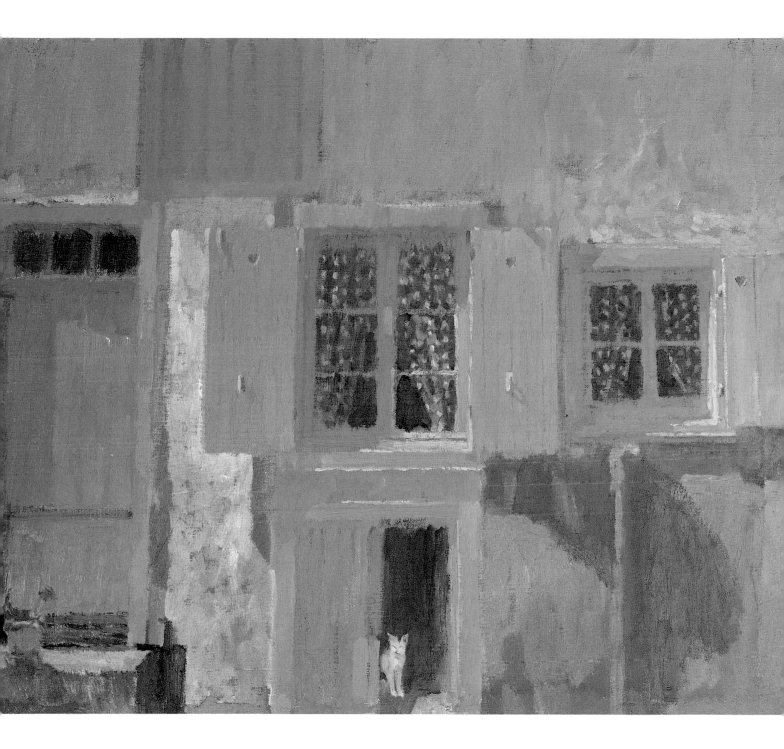

Above: *135. Les Volets Bleus*
Oil on board 43 x 48cm (17 x 19in)
This is an example of a fairly quick,
spontaneous study made on location,
painted on a prepared, tinted board, and
using a limited palette of colours.

For any paintings made on site I think it helps to concentrate on the interesting parts first, such as the figures. Once these shapes are placed satisfactorily, I paint the areas around them. In my experience this makes for a more integrated and successful result than that achieved by adopting the conventional method of starting with the background. Time is always a factor when working on location, and if the background colour doesn't dry quickly then it is more difficult to paint over it with the definition and purity of colour that you may want. Also, superimposed shapes frequently look just that – as though they are an afterthought, worked on top of something else.

Composition

Composition can be defined as the way you arrange the various shapes and content of your subject matter within the picture area. The main elements of the composition are line, mass, tone and colour, and it is the exact relationship of these elements that counts in determining the interest and success of the painting. You may decide to exaggerate certain elements and simplify others, depending on your response to the subject and the impression you want to convey.

One approach to composition is to accept the subject matter more or less as you find it in reality. An equally valid alternative is to place a greater emphasis on interpretation and, in consequence, rearrange what you see to create an entirely different impact. But whatever the approach, composition is always a fundamental and important part of the painting process. For in general, no matter how well a subject is expressed in terms of colour and technique, if the underlying structure and design is weak, then the painting will not be a success.

Below: **136. La Terrasse**
Oil on canvas 111.5 x 109cm (44 x 43in)
The main divisions in this composition, particularly the vertical archway on the right, appear to be based on the Golden Section. In fact, starting with various preliminary sketches, my aim was to create a balance of shapes that is pleasing to the eye – which gave the same result!

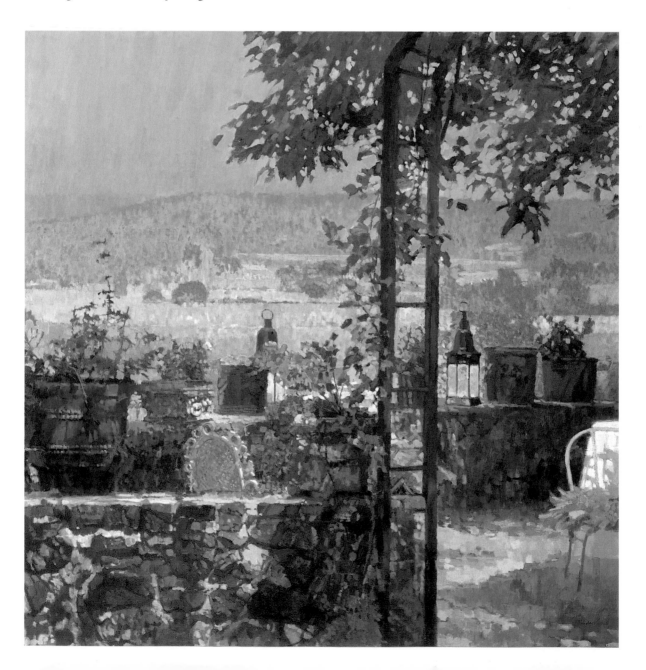

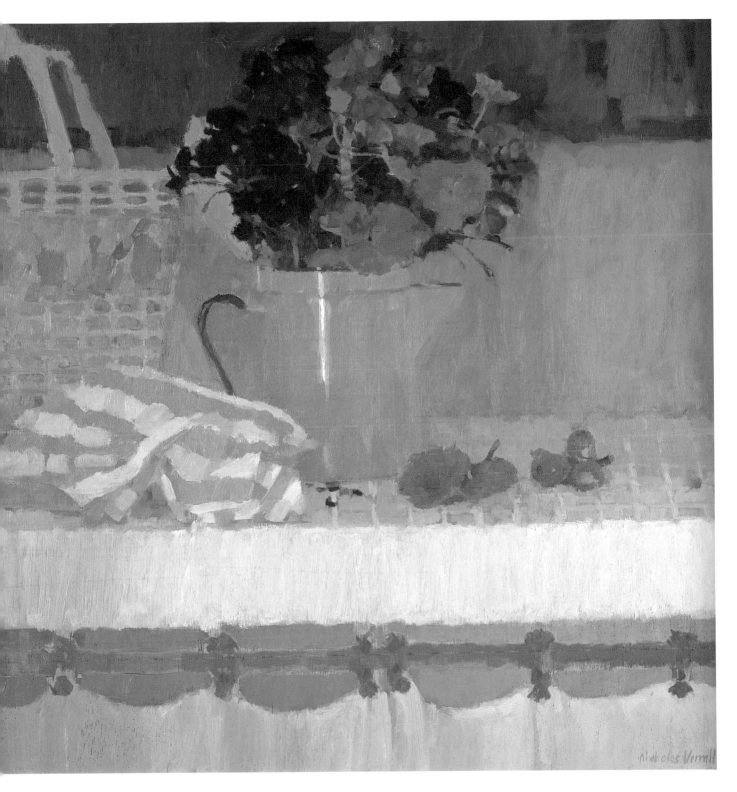

Above: *137. Jug of Geraniums*
Oil on board 51 x 49.5cm (20 x 19½in)
Successful compositions need not be complicated. Simple designs can be equally effective.

Structure and Impact

Some artists think of composition as if it were some kind of mathematical equation, dividing the canvas into certain areas and proportions and then positioning key shapes and colours in particular, defined places. It can work, but equally it can look very contrived. To my mind the composition should be part of the excitement of painting and I tend to rely on whether or not something looks and feels as though it is in the right place, rather than measuring to see if (in theory) it is too near the centre, or happens to be on the Golden Section.

Below: **138. Ox-eye Daisies**
Oil on canvas 122 x 122cm (48 x 48in)
With this type of subject there is always a danger that the composition will lack impact and that the painting will become just a sequence of repeated shapes, rather like wallpaper. Try to find a viewpoint that gives the flowers a directional flow and a centre of interest.

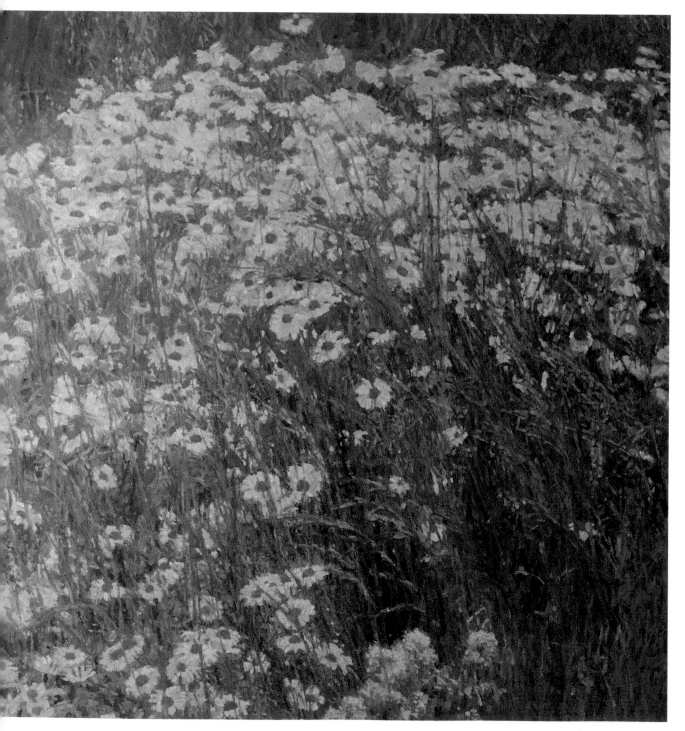

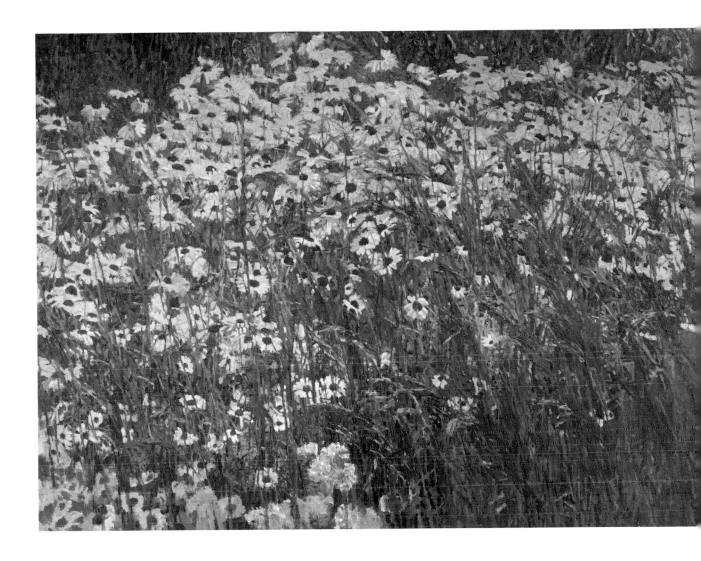

Also, I'm not happy about making too many fixed decisions at the start of a painting. Sometimes the composition can look strange to begin with, but improves dramatically as the painting develops. Having said that, it can help to work with an awareness of different theories and considerations regarding composition, especially to begin with. For instance, generally speaking a painting that depends on equally balanced or totally symmetrical proportions in its basic composition will have far less overall impact than one that does not. Designs that exploit a diagonal or triangular division, or the Golden Section, often work well.

Devised by the great artists and mathematicians of the Renaissance and accepted as having special artistic significance and aesthetic value, the Golden Section is an arrangement or ratio such that the proportion of the smaller part to the larger is the same as that of the larger to the whole. The ratio is approximately 5:8 (strictly speaking it is 0.618:1), although most artists prefer to think in terms of 'thirds'. So, about one-third (or two-thirds) of the way across the painting they will place some significant feature of the composition. The division can be applied in either direction, horizontally or vertically.

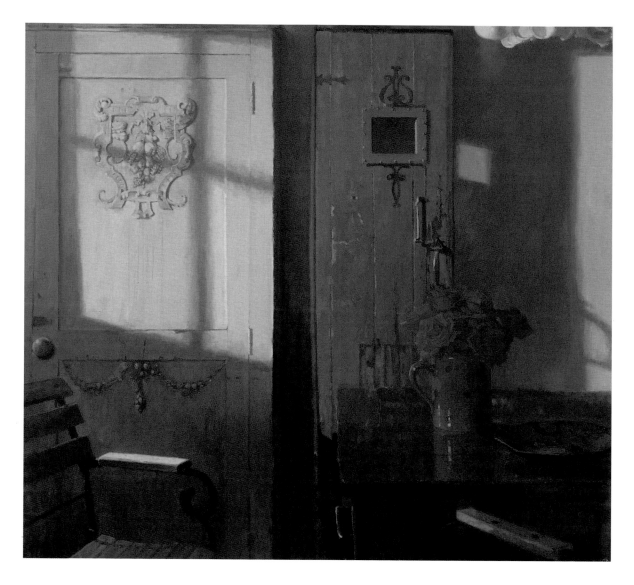

Above: **140. La Porte Verte**
*Oil on canvas 98 x 108cm (38½ x 42½in)
Often, the most interesting compositions
are those that set out to break the 'rules',
as in this painting, with its strong central
dividing line. Degas is one artist who
consistently used very exciting and
unconventional compositions.*

However, I wouldn't regard such theories as 'rules' that must be obeyed at all costs. They are something to bear in mind, but equally it is interesting to devise compositions that contradict the theory, as I have done in *La Porte Verte* (see above). This painting has a strong, vertical dividing line straight through the centre. In theory this would produce a disjointed effect but, by making good use of the shadows and the relationship of the different shapes, I have tried to create a coherent whole rather than a painting with two obvious halves.

We tend to think that it is the size and placing of the shapes that is the most important factor in a composition. This is true, of course, but shapes aren't the only thing to consider. As in *La Porte Verte*, shadows can also play a key part, as can patterns, colours, textures and similar aspects that create contrast and interest – something small against something large, for example. Movement is another quality to consider. In a successful composition the eye travels around the picture, is contained within the picture area, and is led to a centre of interest. In fact, in some paintings, movement is the main compositional device. This is so in both versions of *Ox-Eye Daisies* (see page 118), where your eye is drawn upwards, through the painting, to the top part where there is the most activity and interest.

Above: **141. La Porte Verte**
Composition sketch, fibre pen.

Drama is a vital element in any composition, I think. This may start with drama in the layout (the balance and contrast of shapes), but it can be further enhanced by a drama of light and dark, or contrasts of colours, patterns or textures. As I have explained on page 72, I rarely make any major changes to the content of the subject that I have chosen. But I do compress or expand spaces between objects (though not buildings, as noted in the previous chapter), or perhaps slightly distort the size and proportions in order to establish a stronger element of drama. In *The Decorated Balcony* (see below), for example, I have made the railings taller than they are in reality because this helps create a more dynamic composition.

*Below: **142. The Decorated Balcony***
Oil on canvas 122 x 117cm (48 x 46in)
The exact placing of strong vertical and horizontal lines is always critical. When I make my composition drawings I never start with a 'box' and draw inside it. Instead, I make the drawing and then decide where the edges of the composition should be. This enables me to plan the balance of shapes more successfully.

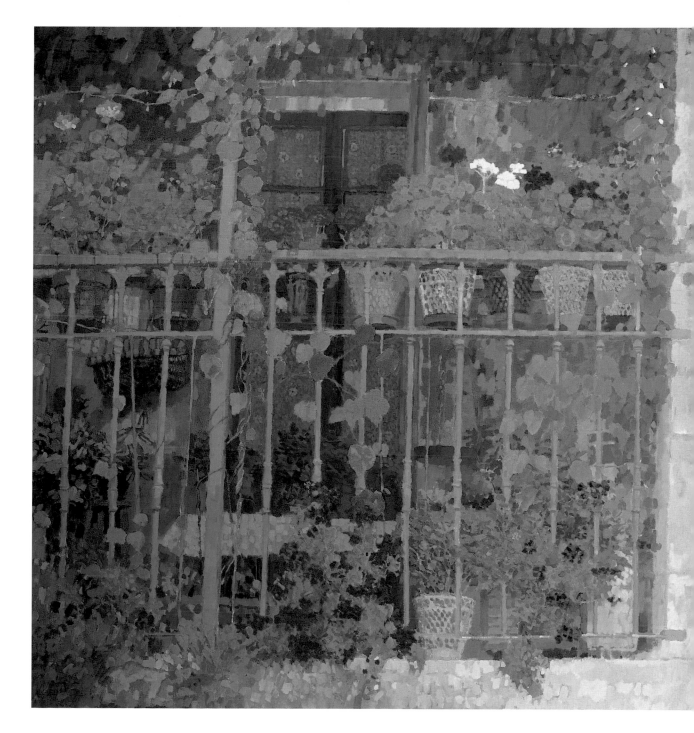

Preliminary Work

In the studio, referring to the location sketches and photographs, I start with some composition roughs to test out different ideas and help me decide which ones to follow up as paintings. Like the location sketches, these little drawings are made in my sketchbook, using fine fibre-tip pens. The drawings measure about 10 x 15cm (4 x 6in) and I work through a sequence of them until I arrive at a composition that I like – one in which the basic shapes create the right interaction between contrast and harmony. See *La Porte Verte* on page 120.

My main objective in the composition sketches is to work out the tonal balance for the painting, and the position and relative importance of the different shapes. Although these sketches do not dictate precisely what happens in the final painting, they help me visualize how the design will look on a much larger scale. In the past, once I had a drawing that I thought would work as a painting, I would then also try out the idea in colour, usually in pastel on dark paper, as in illustration 143 (see below). This would give me a feeling for the light and colour qualities in the subject in addition to the line and tone elements.

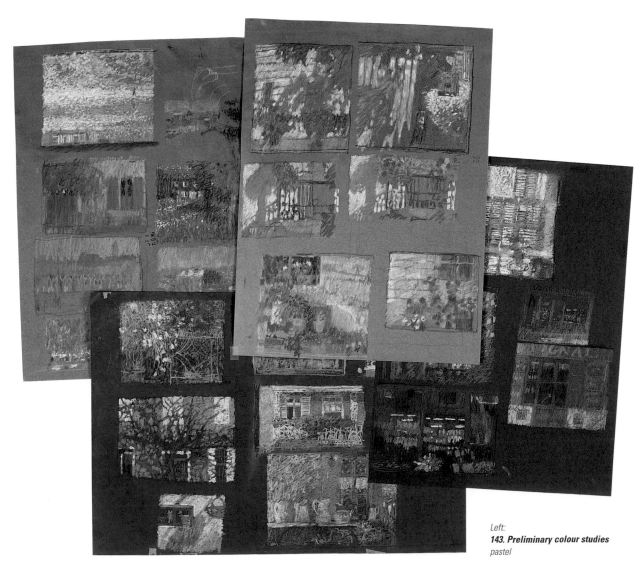

Left:
143. Preliminary colour studies
pastel

However, from the knowledge and experience I have developed over the years I can now manage without the colour drawings, and this gives me a greater freedom in the way that I use colour later on, during the actual painting stage. How much preliminary work you do is a matter of personal choice, but some planning is essential. Preparatory sketches provide a useful starting point for the painting, are a good way of assessing any potential difficulties in the subject, and will give you greater confidence to make a start.

I seldom focus on one idea straight away. Instead, I make composition drawings for various subjects that interest me, sometimes using information from a number of different sources within a single sketch. Then I usually leave the drawings for a week or so before having a fresh look at them to see which ones have the greatest impact. What I hope to find is a composition that is effective, direct and instantly memorable – the sort of idea that you can easily visualize without necessarily referring to the sketch.

Enlarging ideas

If, like me, you want to enlarge your composition drawing onto a canvas or board support, then the first thing to check is that the painting surface is in proportion to the original sketch.

It isn't usually necessary to enlarge the rough idea very accurately, although you will need to get the placing of the main shapes approximately correct. One way of doing this is to use faint matching guidelines drawn across the sketch and the canvas – perhaps diagonal lines and lines made across the centre, in both directions. You can see where different shapes come in relation to these guidelines, and so match them to the corresponding areas on the canvas. If you don't want to damage the preliminary sketch, cover it with tracing paper and draw the guidelines on this.

Another useful method is to draw a grid of squares over the sketch and the canvas, and then redraw the outlines from each square of the sketch on a larger scale to fit the corresponding square on the canvas. I prefer this method, but I keep it quite simple. For a large, rectangular canvas I would use a maximum of sixteen squares, or divisions, for example.

Studio Paintings

My method of painting involves several stages, usually with a drying period between each stage. Consequently, I tend to switch from one painting to another, depending on which stage they are at. I find this process very beneficial in maintaining an excitement for each idea, and sometimes the way that one painting is developing may help my thinking about another.

Essentially my aim in every painting is to express the sense of excitement that I felt for the subject when I first saw it; equally I want to convey the particular qualities of light and colour that impressed me. Of course, every subject is different and has its own identity and sense of place, which means that each new painting requires a slightly different approach. However, there are certain stages of development that are common to most of my studio paintings and I will now explain these in detail, with reference to the demonstration painting *La Véranda au Soleil* (see page 125)

Stages of Development

La Véranda au Soleil was inspired by a scene that I saw in Provence. It was the striking blues and the yellows that initially attracted me to this subject, and I felt that it would have a lot of potential for a large painting in which I could exploit the contrast between the brightly lit building on the upper terrace and the sombre area in the foreground. I made several composition sketches before finding a design that I was happy with, but I had already decided that the view would be face-on, so that the perspective would not dominate too much. The main problem was deciding exactly where to place the balustrade, which runs the entire width of the painting. I did not want to put it right in the centre, but decided instead that the best solution was to make the upper part of the subject more dominant.

I prepared the canvas for this painting in my usual way – by stretching it across a sheet of fibreboard that had been cut to match the proportions of the original sketch. I always use a length of canvas that is several inches larger than the board, folding the edges onto the back of the board and stapling them in place. The extra few inches gives me the option to increase the size of the painting or alter the proportions of the composition at a later stage if I wish.

Top left: **144. La Véranda au Soleil**
(Stage 1)
Oil on canvas 85 x 122cm (33½ x 48in)
Charcoal drawing to show the main shapes of the composition.

Top right: **145. La Véranda au Soleil**
(Stage 2)
Oil on canvas 85 x 122cm (33½ x 48in)
Beginning to block in the underpainting.

Bottom left: **146. La Véranda au Soleil**
(Stage 3)
Oil on canvas 85 x 122cm (33½ x 48in)
The completed underpainting. Beginning to consider the tonal relationships.

Bottom right: **147. La Véranda au Soleil**
(Stage 4)
Oil on canvas 85 x 122cm (33½ x 48in)
Developing the sense of light and mood.

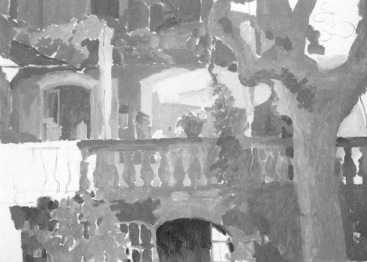

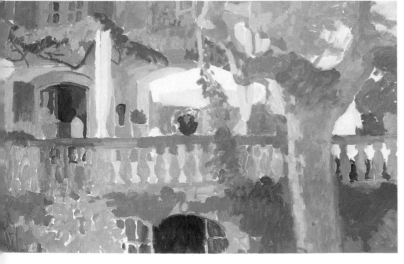

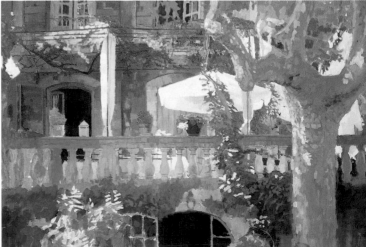

Next, I squared up the canvas and drew in the main shapes, as shown in illustration 144. For the squares, I normally draw on the canvas with a coloured fibre-tip pen, as I want these lines to stay in place. They will eventually disappear into the painting. For the composition drawing I use charcoal, which can easily be rubbed out and altered.

Once I am happy with the initial drawing I begin on the underpainting (see illustration 145). I usually start in the centre or with the most interesting part of the composition and work towards the edges. In *La Véranda au Soleil* I started with the tree. As explained on page 123, I no longer make preliminary colour sketches, so I try to visualize the sort of colour effects I want to finish with, and then choose the colours for the underpainting accordingly.

In general I use weaker versions of the colours I eventually want, or complementary colours, so that I am left with plenty of scope to develop the colour contrasts and intensities as the painting develops. Mostly at this stage I am working with flat areas of colour and middle tones, rather than the strong darks and lights. I keep everything simple: essentially the aim at this point is to create the right balance of shapes and make some initial decisions about colour.

I complete the underpainting in this way, keeping the paint quite thin. Then I leave the picture for a week or more to allow the paint to dry. When I return to it, I first of all check that the design looks right, making any adjustments that are necessary, and then I start to consider the tonal relationships and textures of the various parts of the subject in more detail.

*Below: **148. La Véranda au Soleil***
(Stage 5)
Oil on canvas 85 x 122cm (33½ x 48in)
The final painting, with enhanced passages of colour in places, further contrasts in the lights and darks, and greater detail in the foreground tree and foliage.

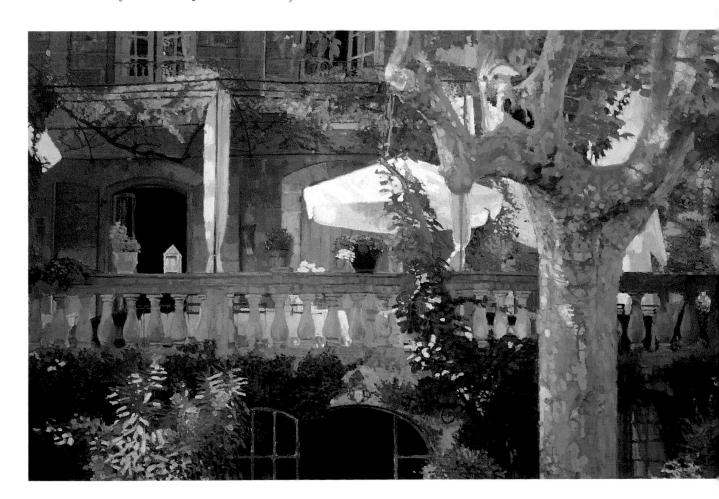

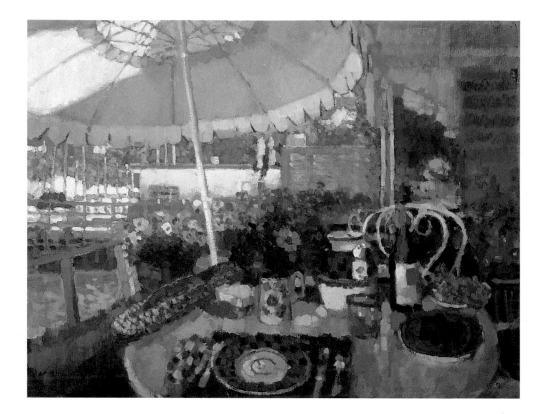

Above: **149. Lunch on the Terrace**
Oil on board 45.5 x 56cm (18 x 22in)
I liked the design possibilities here,
with the shape of the table echoed
above by the parasol, and also the
strong sense of colour.

At this stage in *La Véranda au Soleil* I started to develop the mottled effect on the tree bark and to emphasize the contrast between the smooth, sunlit walls of the building and the dark, textured foliage below. However, I wanted to maintain a freedom and spontaneity with the painting, and so I avoided making anything too defined or exact. I continued to build with blocks and patches of colour, using fairly large brushes (see illustration 146).

Light is always an important quality in my paintings. Usually the effect I try to convey is the flow of light across the subject and the variations of colour and mood that result from this. Consequently, in the next stage of work I concentrate on the particular quality of light that I want for the subject. I begin with the area that contains the most intense effects, which in *La Véranda au Soleil* was the top left-hand corner, and I work from this, following the spread of the light – on the canopy, balustrade, tree, and so on. Then I consider the dark areas, intensifying these where necessary (see illustration 147).

Now, gradually, I began to define the shapes a little more. At this point I was using thicker paint, especially in the brightest areas, and smaller brushes. If something looks wrong, I tend to leave that part to dry and then paint over it, rather than remove the wet paint. I quite like the encrusted effect that results when an area is repainted in this way.

I then let the painting dry. At this stage, I would normally work through until it is finished, the only exception being when I come across a problem that I can't decide how best to solve. In that case I will leave the painting until I have thought of a solution.

In the final stages I work on the details – for example, the little pots on the balcony in *La Véranda au Soleil* – and aspects such as the balance of flat pictorial

Below: 150. *The Blue Shutters, Provence*
Oil on canvas 104 x 129.5cm (41 x 51in)
This subject has all the elements that excite me about painting – the interaction of shapes, patterns, textures and colours, and the influence of light to create a particular mood.

space and three-dimensional qualities. In this painting it was quite difficult to make the tree look three-dimensional while still fitting into the surroundings and not jumping forwards too much. At the very end it is usually a matter of enriching some of the darks with further glazes of colour, and perhaps enhancing the overall mood of the scene, again with warm or cool glazes.

It is difficult to say why a painting looks finished. Generally it is when it has reached the point where it feels complete; where nothing is out of place. Beyond that point, further work seems to add very little to the impact of the painting, and indeed can do much more harm than good in many cases. I leave my finished paintings for a month or two and then I have another look at them – often inviting a friend along to see what they think – before deciding whether anything should be added or altered.

In conclusion, I hope you have enjoyed discovering what painting means to me and I hope that my thoughts and observations will prove useful in your own work. The main point to remember about painting is that it should involve a personal response. Practical skills are essential, but their value is diminished if they cannot be used to help you to freely express your ideas in your own particular and individual way.

Index